S0-BQX-988

ELISABETH FRINK

Sculpture and Drawings
1950-1990

THE NATIONAL MUSEUM OF WOMEN IN THE ARTS
WASHINGTON, D.C.
1990

THE EXHIBITION IS MADE
POSSIBLE BY A GRANT
FROM GLAXO INC.

Designed by Miles Fridberg Molinaroli, Inc. Washington, D.C.

Printed by W. M. Brown & Son, Richmond, Virginia

Library of Congress Catalogue No. : 90-060050

ISBN 0-940979-12-8 (Clothbound)

ISBN 0-940979-13-6 (Paperbound)

© 1990 The National Museum of Women in the Arts,

Washington, D.C.

Cover: *Front Runner*, 1986
Bronze, edition of 4
77 in. high
Photograph by Jorge Lewinski

ACKNOWLEDGEMENTS

T his exhibition of Dame Elisabeth Frink's sculpture provides a fitting occasion for us to mark the third anniversary of the museum in its permanent home. We are reminded that its mission is both national and international in scope and that we must strive to make the cultural endeavor that the museum represents meaningful to all people.

The 1990 Gala Benefit Opening of the exhibition *Elisabeth Frink: Sculpture and Drawings, 1950-1990* celebrates this artist's extraordinary personal achievement and the anniversary of our institution, which is dedicated to highlighting the accomplishments of women in art. The Benefit Opening is presented under the Gracious Patronage of Mrs. George H. W. Bush and the Honorary Chairmanship of the Ambassador of Great Britain and Lady Acland. We wish to thank Mrs. Bush and Sir Anthony and Lady Acland, and to express our appreciation for the efforts of Mrs. Climis G. Lascaris, the capable Chair of the event.

This first major retrospective of Dame Elisabeth Frink's work in the United States was made possible through the generosity of one of the museum's most prestigious Corporate Members, Glaxo Inc. We are truly grateful to Dr. Ernest Mario, Chairman; Dr. Charles A. Sanders, Chief Executive Officer; Mr. Thomas W. D'Alonzo, President; Mr. Stephen R. Conafay, Senior Vice President of Corporate Affairs; and others from Glaxo for their very kind assistance and cooperation.

Clearly, the exhibition would not have been possible without the inspiration of Dame Elisabeth and the help of her husband, Alexander Csaky. Also, Catie Baker, Dame Elisabeth's assistant, proved unfailing and untiring in her attention to the numerous details that are essential to making an endeavor of this scale a reality. Kenneth Cook's invaluable assistance with the installation of the sculptures at the museum helped ensure that the show reflects the artist's sensibility in every detail.

Although the artist's work previously has not been presented by a museum in the United States, her sculptures have been collected widely by individuals and institutions both here and abroad. We thank the collectors who kindly have cooperated with the museum by loaning for the exhibition: Mr. and Mrs. Leo A. Daly III, Edward J. Bernstein, the Hirshhorn Museum and Sculpture Garden of the Smithsonian Institution, Evelyn Stefansson Nef, Benjamin D. Bernstein, Robert Liberman and Mr. and Mrs. Gerald L. Parsky have all been generous in sharing art from their collections.

We are fortunate to enjoy the support and assistance of many diligent and kindly staff members of the Embassy of the United Kingdom and Northern Ireland.

Special pride is also taken in the catalogue, handsomely designed by Miles Fridberg Molinaroli and featuring an essay by the British scholar Bryan Robertson.

At the museum, Rebecca Phillips Abbott, Deputy Director, played a crucial role in coordinating details of the exhibition on this side of the Atlantic. Brett Topping edited the catalogue. The museum's curatorial staff—Helaine Posner, Susan Sterling, Stephanie Stitt and Susan Kitsoulis—worked diligently to produce an exhibition worthy of Dame Elisabeth's exceptional work and one which we are sure will bring much pleasure to the many visitors who attend.

My gratitude and warm best wishes to the many involved.

Wilhelmina Cole Holladay
President

Glaxo Inc. is pleased to join The National Museum of Women in the Arts in presenting the work of Dame Elisabeth Frink to the American public and visitors to our nation's capital.

For more than forty years Dame Elisabeth has been a leading British sculptor. Appreciated around the world, her extraordinary work reflects an intense personal vision that expresses both strength and determination.

A British company with a significant presence in the United States, Glaxo is committed to enhancing the quality of life in communities around the world. By sponsoring the first major retrospective of Dame Elisabeth's work in America, Glaxo strengthens the historic cultural bonds that link the United States and the United Kingdom. The exhibit embraces both the cultural differences and similarities between our countries and, in doing so, widens the circle of artistic appreciation.

We are proud to be a part of this enriching experience.

Charles A. Sanders, M.D.
Chief Executive Officer
Glaxo Inc.

ELISABETH FRINK

BY

BRYAN ROBERTSON

PART I

THE IDENTITY

OF THE SCULPTURE

For four decades Elisabeth Frink has made eloquent sculptures that take their place with unselfconscious dignity in England's public spaces and private homes. The truthfulness and emotional content of her work have an appeal that cuts across the usual social divisions of education or privilege. Her work is admired by the public at every level and can be found in a variety of institutions, from great museums to college art departments. Frink's subjects are basic and familiar—men, horses, birds and dogs. These are subjects that she understands fundamentally. It is a measure of her artistic and imaginative integrity (for which an exceptional purity of spirit is the bedrock) that her art, for all its accessibility to a wide audience, never resorts to academic formulas or clichés. An occasional personal mannerism does appear, but this could be said of strong painters or sculptors throughout history, and it does, after all, identify their work.

In truth, just as the lyrical or romantic content of Frink's work finds its form organically, from within, rather than in mannered or contrived surfaces and stylized shapes, so also does its puritan quality, the almost ethical scrupulousness of Frink's vision, reject stylistic tricks, formulas or obvious blandishments. The same could be said of any great sculpture, from the works of Auguste Rodin to those of Henry Moore. It is important, however, not to accept without reflection the apparent ordinariness, the almost prosaic severity, of Frink's plain figures with their straightforward actions and thoroughly matter-of-fact postures. The sculptural presence of every piece is pared down to essentials. Her work is so lacking in exhortative, emotional or theatrical fat that the slightest falsity of feeling, effected by academic ploys in the handling of form or gesture, would be instantly and glaringly obvious.

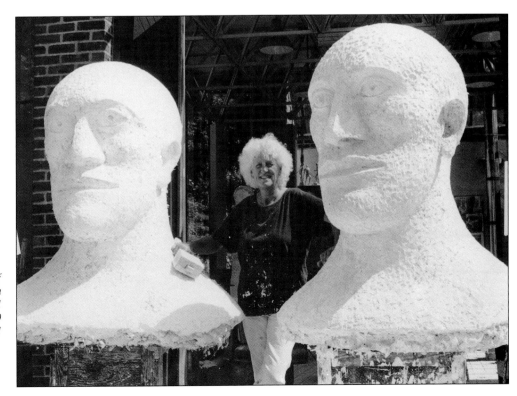

*Photograph of
Artist's Studio with
Desert Quartet I and
Desert Quartet II , 1989
Photograph by David Buckland*

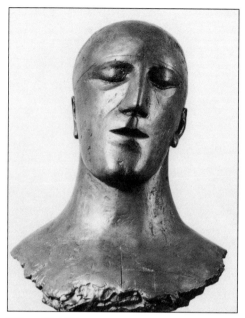

Tribute III, *1975*
Bronze, edition of 6
27 in. high

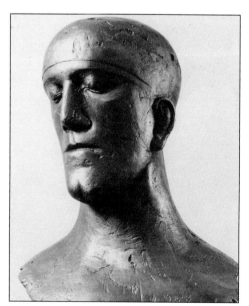

Tribute IV, *1975*
Bronze, edition of 6
26 in. high

Frink's affinity for plainness and compression—the apparent simplicity of her sculpture arising from a highly sophisticated approach to form that always yields to a straight and level vision—connects her work to some of the carvings made for England's churches and cathedrals between 1100 and 1500. The same sculptural qualities that shape the life-like head and shoulders of a donor, glimpsed through the foliage of a carved, wooden rood screen, or the recumbent stone effigies of a knight and his lady who appear to be asleep also may be ascribed to Frink's taut heads and figures, birds and animals. Looking at the somnolent face of a victim in the *Tribute* heads of 1975, it also is possible to see a connection with the strong, refined art of the Khmer civilization, notably pieces from the Sukhothai period. So, too, the *Running Man* (1980) may be seen as kindred to the equally calm, intensely humanistic sculptures of the Sumerian civilization. Thus, the restrained, unprententious forcefulness of Frink's sculpture is a recurring characteristic of Eastern and Western sculpture. This direct quality can also be seen in the works of other sculptors, from Giovanni Pisano to Pablo Picasso. The determining element in Frink's case, however, is a northern humanism, somewhat Gothic in its restraint, tempered by a love for and an awareness of southern aesthetic principles.

In 1949 I was directing a small art gallery in Cambridge. One day some local collectors asked if they could introduce me to their friend's gifted daughter, who was just about to commence her studies at the Chelsea School of Art. I agreed, and so came my first meeting with Elisabeth Frink. She was about eighteen and somewhat embarrassed by the kindly enthusiasm of her mother's friends. Although I was only twenty-three at the time, about the same age as the undergraduates who frequented the gallery, I must have seemed formidable to the young Frink, meeting me as she did amid the public

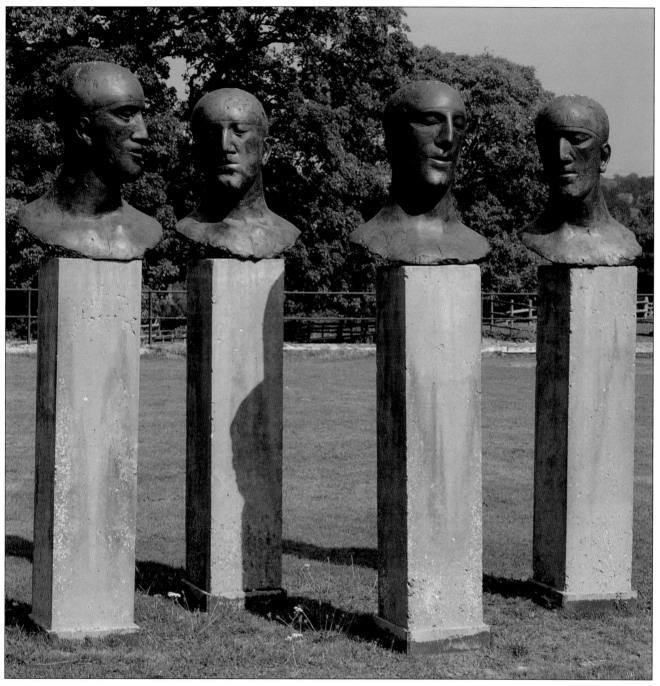

Tribute I-IV, *1975*
Bronze, editions of 6
27 in.; 27 1/2 in.; 27 in.; and 26 in. high
Photograph by Mark Fiennes

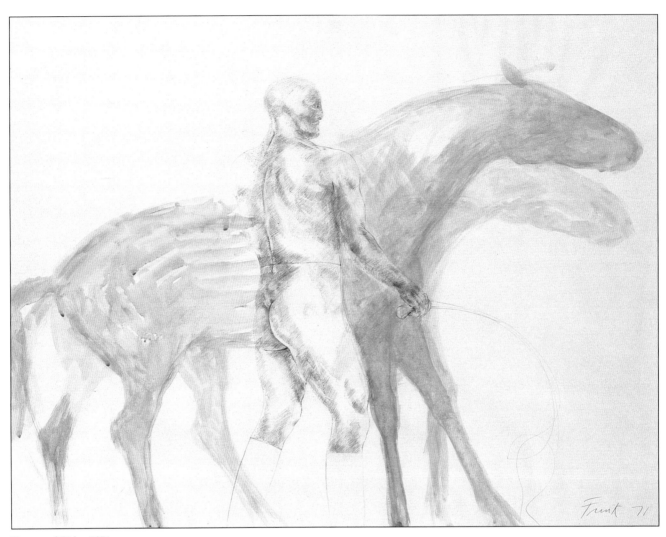

Horse and Rider, 1971
Watercolor and pencil
30 x 40 1/2 in.
Photograph by Edward Owen

bustle and noise of a department-store gallery. What I saw in her portfolio, presented in pained silence by the artist, was a number of deeply impressive drawings—powerfully muscled and tendoned men sitting, naked, astride plunging, rearing or galloping horses. The men seemed to be blinded; at least, their faces were heavily shadowed. A sensation of wildness, alarming speed and power was conveyed by the images of the horses and the tense postures of the men mounted upon them. There were no archaic touches, such as flying draperies; however, there seemed to be a slight connection between the male figures and certain Renaissance prototypes, notably the work of Luca Signorelli, and a few marginal visionary qualities reminiscent of William Blake. These were plainly apocalyptic studies—the Four Horsemen of the Apocalypse, no less—and they seemed a potent beginning to Elisabeth Frink's career.

In the same portfolio were several equally strong depictions of birds. Predatory and threatening with steely talons and outstretched wings, they were filled with a sculptor's sense of three-dimensional form. These were drawings of birds in their own right, not symbols of human stress.

In the next year or so, while Frink was still a student at Chelsea, an emphatically menacing and rather baleful type of sculpture came to prominence in England. Through the harshness and coldness of welded metal and sharply uneven forms, the new sculptural style captured certain aspects of postwar angst. Elisabeth Frink was not influenced by the work of her contemporaries. She contributed to the postwar mood in sculpture by her own personal and restrained sense of tragedy. The stoic impulse and character of her work reflect an inner strength she has possessed since childhood and a resolve which was apparent even before she entered art school. Frink grew up during World War II. Her father was at Dunkirk, and the family lived near an

Winged Beast, *1962*
Charcoal
30 x 22 in.
Photograph by Edward Owen

airfield in Suffolk where bombers often returned to base in flames. As a schoolgirl, the artist remembers hiding from the machine gun attack of a German fighter plane. The war, with its horrible final disclosures of the death camps through photographs and newsreels, was as much a part of her childhood as the countryside, animals and family life.

Frink's sense of vitality is very strong. All of her figures, despite the constraint of their impassive, muscular energy, have a special quality of survival, endurance and vigilance. Her sculptures may appear in some ways to hark back to ancient figures in medieval churches and cathedrals, but they also are essentially post-Freudian in their representation of the violent aspects of masculinity and the blank face of aggression. Her goggled heads are as menacing and memorable as those fatalistic images of mortality—the motorcyclists that attend Death in Jean Cocteau's *Orphée*. She has never in her life made a mark on paper, let alone modeled a sculpture, which was not inspired by a deep conviction of the power of the imagination and a passionate need to add some measure of her own spiritual awareness of life to the collective pool of human experience. Her outdoor sculptures are among the most successful of our time, because they look as if they have always existed, not merely decorating but inhabiting our common space.

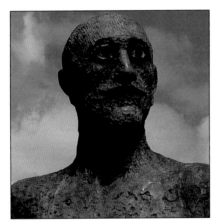

(Detail) Riace IV, *1989*
Bronze
87 in. high

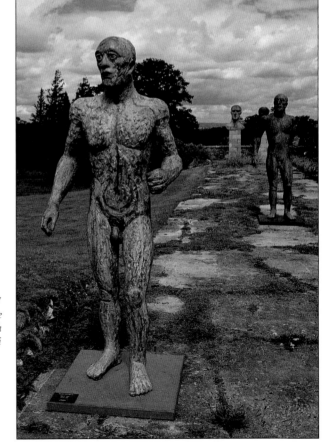

Riace II, *1987*
Bronze
86 in. high
Photograph by Jorge Lewinski

(Opposite) Riace IV, *1989*
Bronze
87 in. high
Photograph by Jorge Lewinski

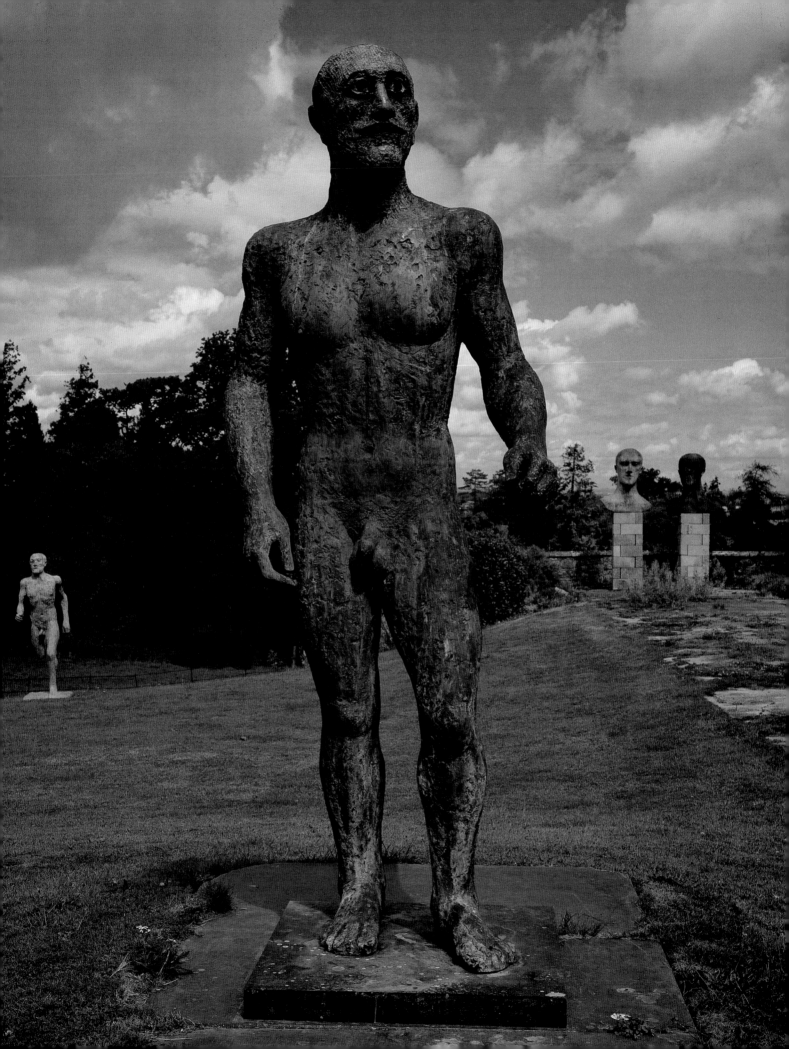

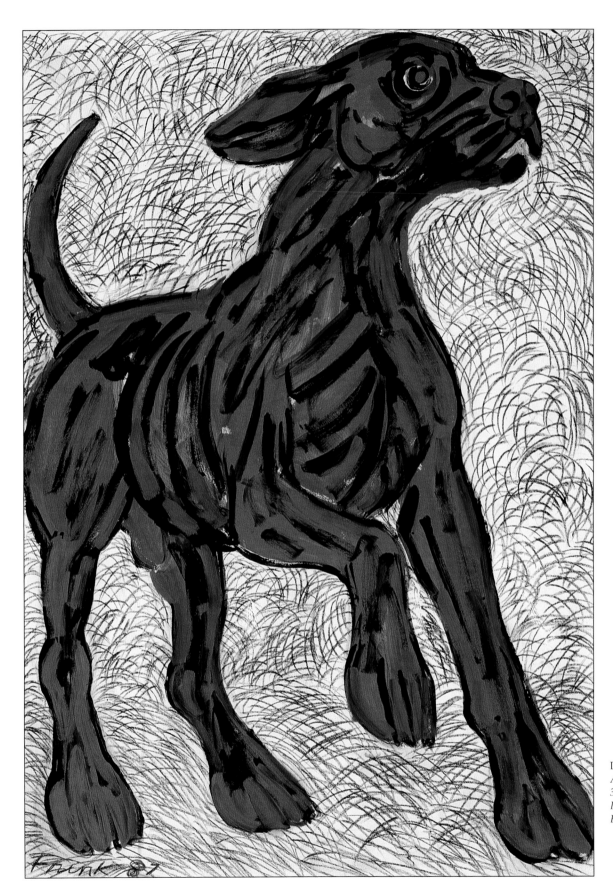

Dog, 1987
Acrylic and chalk
39 3/4 x 28 1/2 in.
Photograph by
Edward Owen

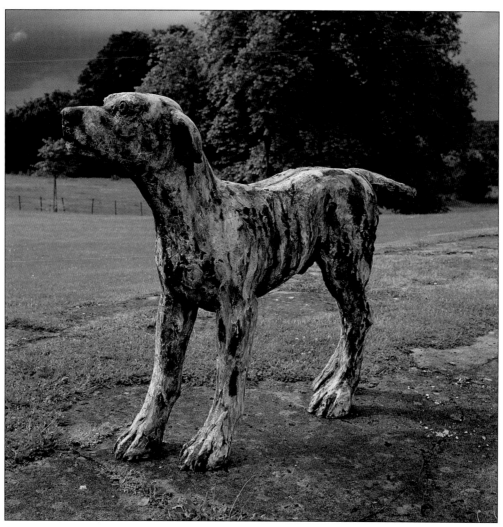

Dog, *1980*
Bronze, edition of 6
31 x 43 in.
Photograph by Jorge Lewinski

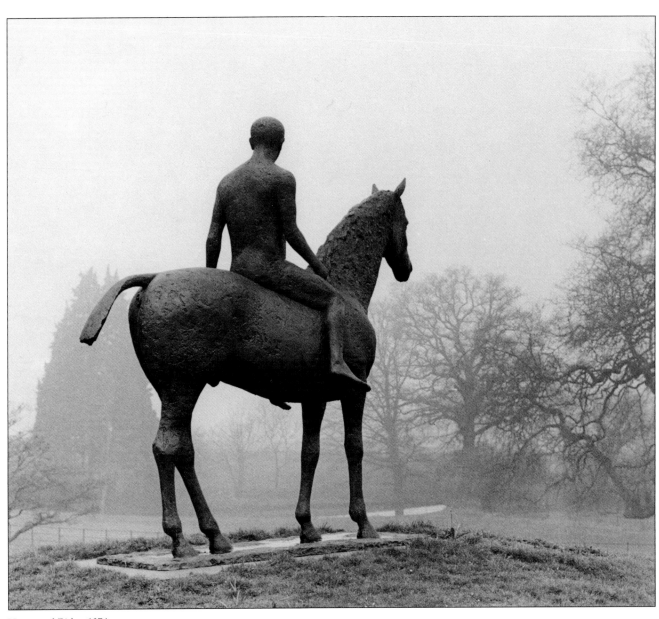

Horse and Rider, 1974
Bronze
96 x 96 in.
Commissioned by Trafalgar House for
Dover Street, London

PART II

THE

CONTEXT

As a young sculptor, Elisabeth Frink had some slight advantage in arriving on the creative English scene in the early 1950s, when there was a general recognition of Henry Moore's genius. It is useful in assessing Frink's professional context to realize the extent of the huge shadow cast at that time by Moore's work for any sculptor of Frink's generation.

Moore's pre-World War II work had been incomprehensible to the public at large and was purchased by only a small number of enlightened collectors. Until the 1940s he lived and created art on the margins of poverty. With the advent of the war, his patron and friend Kenneth MacKenzie Clark, the youthful Director of the National Gallery in London, also was appointed director of a newly created board of government officials and arts administrators which commissioned artists to record the war through paintings, drawings and photography. They worked among the fighting forces in action abroad or in England on what was called the home front. Their assignments might mean documenting anything from the appalling devastation caused by the aerial bombardments endured by the civilian population in most of Britain's cities to recording the lives of factory workers, the configuration of airfields or the routine of troop training camps.

Knowing of Moore's origins in a Yorkshire coal-mining family, and being fully aware of his love of penetrating wood or stone in his sculpture, Clark had the inspired idea of asking Moore to explore scenes of civilians using the public air-raid shelters during bomb alerts and taking nightly refuge in London's underground tube stations. There, men, women and children bedded down along the public platforms with blankets, mattresses and provisions. The long rows of tightly packed, sleeping, or fitfully wakeful, figures had a nightmare poignancy, dramatized by the lurid nighttime

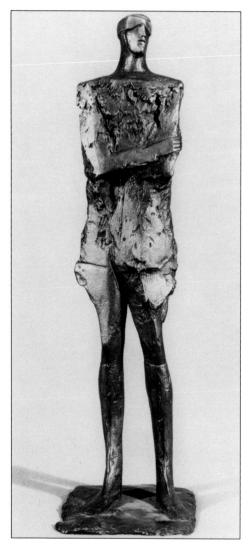

Helmeted Man with Goggles, *1968*
Bronze, edition of 7
26 3/4 in. high

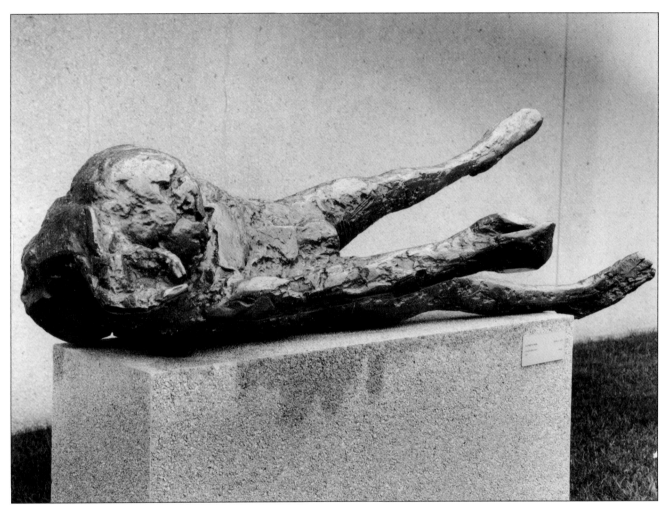

Fallen Birdman, *1961*
Bronze, edition of 3
21 5/8 x 62 7/8 in.

lighting. I occasionally witnessed these scenes as a schoolboy, and the drawings that Henry Moore made from his nocturnal ramblings around the London shelters are still, to me, tremendously affecting. The scenes were indeed heart-rending. Moore's superb drawings reconcile, without sentimentality, the dehumanizing effects of these nightly imprisonments—the recumbent, covered bodies laid out in endless rows like corpses—and the all-too-human vulnerability of sleeping heads caught in close-up, with gaping mouths and darkly cavernous nostrils. In all of the depictions, Moore's emphasis remained human endurance and stoicism in the face of brutishness and oppression.

Because of these air-raid shelter drawings, Moore became a national figure by the middle of the war. They provided a foundation for his exploration of a new theme: the family group, the symbol of social strength, unity, harmony with the eternal cycle of nature and multiple other associations. Many of Moore's family groups, with their own understated monumentality, are extremely beautiful. The theme had a particularly personal resonance for

Moore because of his wife's long-awaited pregnancy, which occurred relatively late in life. The Moores' only child, their daughter Mary, was born in 1946.

Thus, during the 1940s Moore made drawings and sculptures which spoke to everyone. Although his dismembered, reclining figures and other less accessible works continued to arouse varying degrees of incomprehension, or even derision, from that period of his career he became a predominant figure in English art. Moore's position springs from a peculiar convergence of circumstances. To this day he retains a special place in the English cultural hierarchy, and the appreciation of him was never stronger than in the 1950s.

The war years affected the American and English art scenes in decidedly different ways. Max Ernst, Fernand Léger, André Masson, André Breton, Roberto Matta, Yves Tanguy, George Grosz and other distinguished European artists lived and worked as émigrés in the United States from 1939 to 1945, influencing American artists and sowing seeds that would mature in later generations. In England,

Torso, *1958*
Bronze, edition of 3
13 x 39 in.

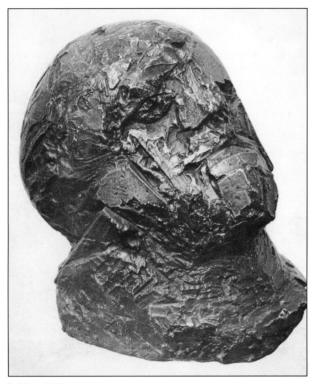

Soldier, *1963*
Bronze, edition of 6
14 in. high

however, artists who were not away in the armed services were reduced to thumbing over old copies of *Verve, Minotaure* or *Cahiers d'Art* for aesthetic stimulation in the face of an almost total five-year isolation. This situation produced a bitter-sweet, romantic figuration in English painting which did not extend beyond the war years. By contrast, developments in sculpture, apart from Moore, seemed to be at a standstill until 1945-46.

The mood had changed by the early 1950s from wartime isolation and near claustrophobia to a sense of freedom and renewal which continued into the later years of the decade. The heightened awareness of society's potential for violence caused by the use of the hydrogen bomb and the horror unleashed by the opening of Belsen, Dachau, Ravensbrück and the other hideous death camps was gradually tempered by hope. The newly formed United Nations, the rebuilding taking place in stricken parts of Europe and the expansion of everyone's aesthetic horizons following the loss of contact during the war years all added to the feeling of security and confidence.

Concurrently, in the late 1940s and increasingly through the 1950s, there was a resurgence of the sculptural arts across Europe, with artists like Alberto Giacometti, Cesar Baldiccini, Ernst, Joan Miró, Henri Matisse, Marino Marini and Giacomo Manzu coming to the fore. Alexander Calder and David Smith also were highly visible by the end of the 1950s. The opportunity to view the work of those artists provided new inspiration to English sculptors.

The prizes and critical accolades received by Moore after the war, along with his growing prestige abroad, also made the English more receptive to the idea of sculpture as an independent activity, unrelated to monuments and memorials. One of the immediate results of the national esteem felt for Moore, therefore, was an increase in sculpture

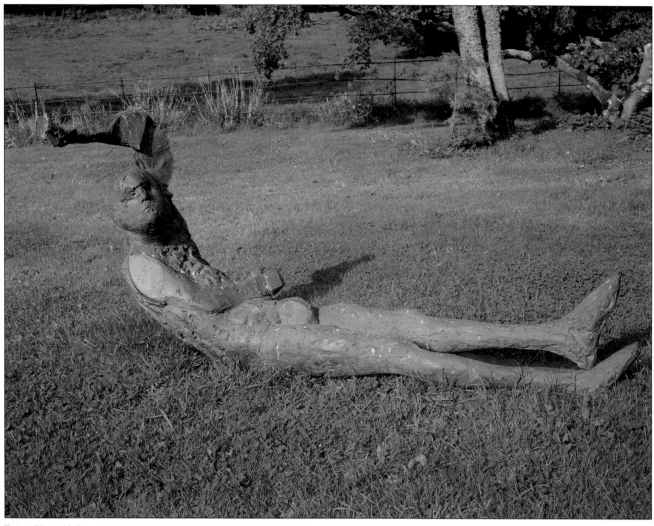

Dying King, 1963
Bronze, edition of 3
35 1/2 x 78 in.
Photograph by Jorge Lewinski

exhibitions and sculptural events. The moment the war ended, large outdoor assemblages of sculpture in London parks became regular occurrences. Works by Calder, Smith, Giacometti, Germaine Richier and others accompanied those of Moore, Barbara Hepworth and younger British artists. Public bodies and educational authorities also began to hand out sizeable commissions for sculpture. Thus, when Elisabeth Frink left art school in 1952, contemporary sculpture in England was at last considered to be on equal terms with painting. This situation was without precedent.

Following the completion of the cathedrals at the end of the 15th century, which contain great sculptural works by anonymous artists, there had been little sculpture produced in England except for war memorials and a few distinguished equestrian pieces sculpted in London in the 18th century. In other words, there was no tradition for English sculpture prior to the appearance of works by Sir Jacob Epstein in the early years of the 20th century

and Moore and Hepworth in the 1930s. The lack of a long-established English sculptural tradition allowed Frink the freedom to experiment with some of the more radical features of 20th-century sculpture.

The work of a younger generation of sculptors—including Reginald Butler, Lynn Chadwick, Kenneth Armitage and Bernard Meadows—Elisabeth Frink's senior contemporaries, enjoyed a degree of respect and serious attention through the 1950s because of its strength. It also flowered in that receptive climate made possible by Moore's example and international success, although none of these artists was influenced directly by Moore. His stature at mid-century notwithstanding, there was no "school of Moore," no followers per se. The younger sculptors felt his figurative work, such as the family groups which included the popular *Madonna and Child* stone carving for the parish church of Northampton, marked a populist digression from his fiercer, more sharply abstract, earlier works. Even his undeniably grand postwar creations were

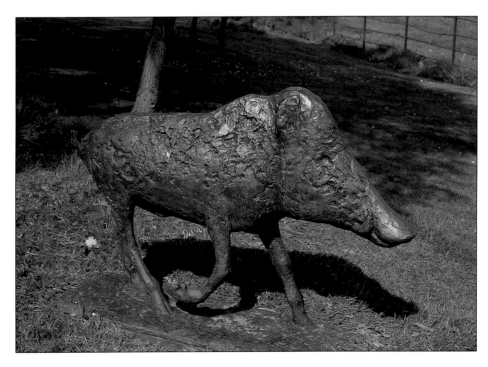

Wild Boar, *1975*
Bronze, edition of 6
28 x 39 in.
Photograph by Jorge Lewinski

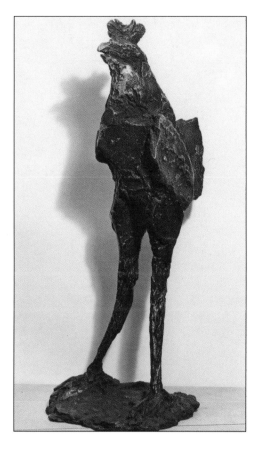

Cock, *1961*
Bronze, edition of 9
25 in. high

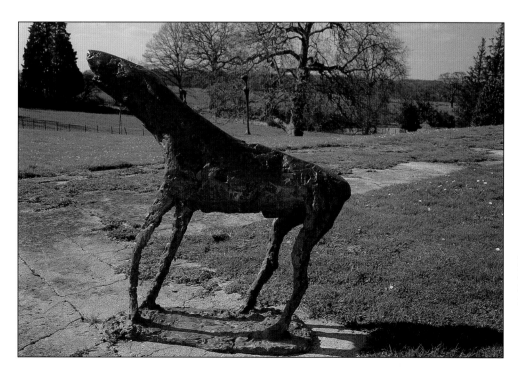

Dog, *1958*
Bronze, edition of 4
38 x 38 in.
Photograph by Jorge Lewinski

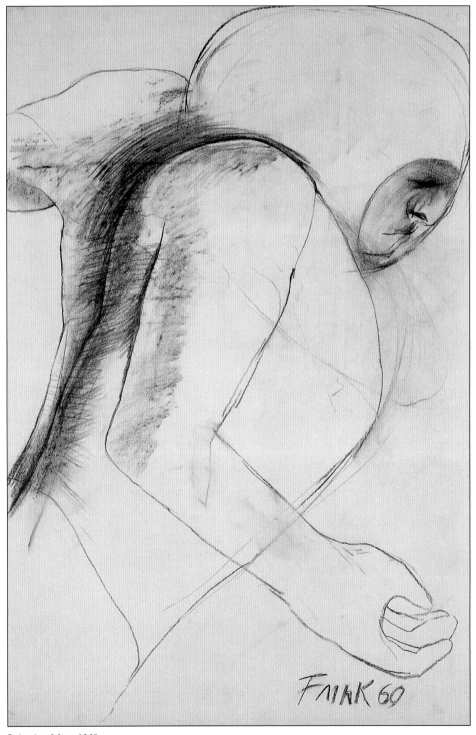

Spinning Man, *1960*
Charcoal
30 x 20 in.
Photograph by Edward Owen

suspect because of their very grandeur. *King and Queen* or *Falling Warrior*, for instance, seemed faintly Wagnerian in tone, however bony and tough in form. Moore also was attacked for a kind of fake humanism by the Marxist-oriented critic John Berger, in a famous diatribe entitled "Piltdown Sculpture" in the February 27, 1954, issue of *The New Statesman and Nation*. Berger's view went too far for most major sculptors, but they certainly reacted against Moore stylistically. More generally, they also felt there was a tendency toward rhetoric in some aspects of Moore's work.

Ultimately, therefore, the 1950s was a decade in which English artists pulled together several different strands in modern sculpture that the war years had prevented them from exploring. Butler, for instance, made welded images incorporating the concept of a human presence, figure or relic caught in a contraption or device, a theme stemming from Giacometti's prewar *Invisible Object (Hands Holding the Void)*. But-

ler's watchtower sculpture, which won the main prize in the 1953 "Monument to the Unknown Political Prisoner" competition—in which the twenty-two-year-old Elisabeth Frink also won a prize—was a more abstract distillation of those principles. In other ways, Butler explored fetishism and a kind of tough, semiprimitive imagery in welded metal. Before he commenced his repetitive series—large-cast female figures balanced on grids—Butler made some highly individual sculptures in a neo-Surrealist vein.

At that time Chadwick created images from constructed elements—with chunks of prismatic glass suspended in metal tripods—which were distantly reminiscent of Calder.

Armitage followed a more directly figurative path, avoiding the emotionally saturated Expressionist distortions that Richier's example had stimulated in Europe and sustaining a more delicate

Spinning Man II, *1960*
Bronze, edition of 3
19 x 72 in.
Photograph by Jorge Lewinski

Horse's Head, *1963*
Bronze, edition of 6
10 1/2 x 18 in.

Plant Head, *1963*
Bronze, edition of 6
29 in. high

lyricism. Armitage's *People in a Wind* and playfully
erotic, if schematic, images of young girls with
spindly arms and legs (in part derived from pho-
tographs of pubescent natives in Claude Levi-
Strauss's book *Triste Tropiques),* were original and
affecting. They shared a common ground with the
new, Etruscan-inspired humanism pioneered by
Marini and Manzu.

Of the postwar English sculptors, Elisabeth
Frink's teacher at the Chelsea School of Art, Bernard
Meadows, was perhaps the most conservative in his
imagery. Before the war he had worked for many
years as Moore's devoted and proficient studio
assistant. Serving in the Royal Navy during the war,
he was stationed for a lengthy period in the Cocos
Islands. There the big, scuttling land crabs, with
their huge claws that waved menacingly under
threat, fascinated him. After the war, at about the
time that Frink was studying with him, Meadows
began work on a long series of sculptures reflecting
opposing themes. His variations on the crab shape
projected an aggressive, armored, predatory image.
Later Meadows sculpted a series of variations on a
cockerel image, abstracted like the crabs to
quintessential shapes. The bird images, with their
freely modeled surfaces, expressed panic, hysteria,
vulnerability. Meadows was using these creatures,
like the crabs, as surrogates for human states of rage
or fear. Meadows's images, which were extraordi-
narily beautiful and impressive in themselves, rep-
resented something new in English sculpture.
Works by earlier sculptors—Gertrude Hermes or
Leon Underwood, for example—presented ideal-
ized or slightly abstracted bird or animal forms,
such as one also finds in the work of the American
sculptor John Flanagan. To invest a bird or animal
form with human pathology, as it were, without
lapsing into caricature, was a new achievement.
Picasso's wartime assemblages in a similar vein, for
example, were striking but facetious.

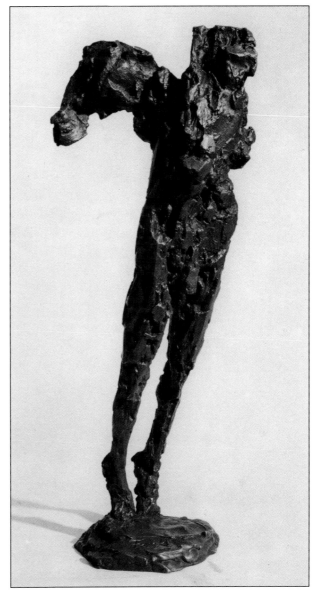

Winged Figure, 1959
Bronze, edition of 6
24 in. high

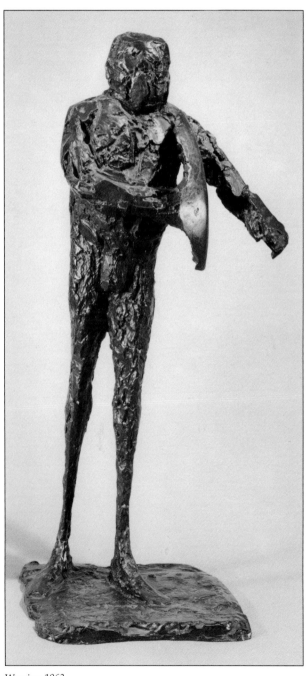

Warrior, 1963
Bronze, edition of 6
24 1/2 in. high

Meadows also appreciated the special strengths of the painter-sculptors—Pierre Auguste Renoir, Edgar Degas, Matisse, Miró and Picasso—particularly their fluidity and freedom of expression. This insight offered a fresh point of view which affected the thinking of his students.

Such were the disparate factors constituting the professional scene in England that greeted Elisabeth Frink. Her mentors from among the older generation were making good the lost war years: catching up with formal devices, exploring a freshly licensed humanism, welding for the first time, digesting the sophisticated infantilism of Jean Dubuffet and *l'art informel* of Alfred Otto Wols and Jean Fautrier. American Abstract Expressionism would soon invade Europe, registering its fearsome extremities on the canvases of Francis Bacon. Sculpture was edging toward the same freedom as painting; the creative mood among sculptors in London was open and adventurous. Yet a kind of stoic, Existential density—a vestige of the war—persisted until the late 1950s. American sculpture was relatively unknown in England at this time. Calder was celebrated among the art community and a small public, but Smith was hardly known at all until the late 1950s. The generation of sculptors that included Richard Lippold, Seymour Lipton and David Hare has never penetrated English awareness. Frink's frame of reference, therefore, ranged from the obvious European masters to the more recently celebrated Richier and the later work of Giacometti.

Characteristically, Frink practically ignored all the stylistic trends around her. Her first standing, seated and reclining figures—male and female—as well as her bird images, were fully modeled and entirely personal. Strong and alert, they possessed a faintly ominous, acrid presence.

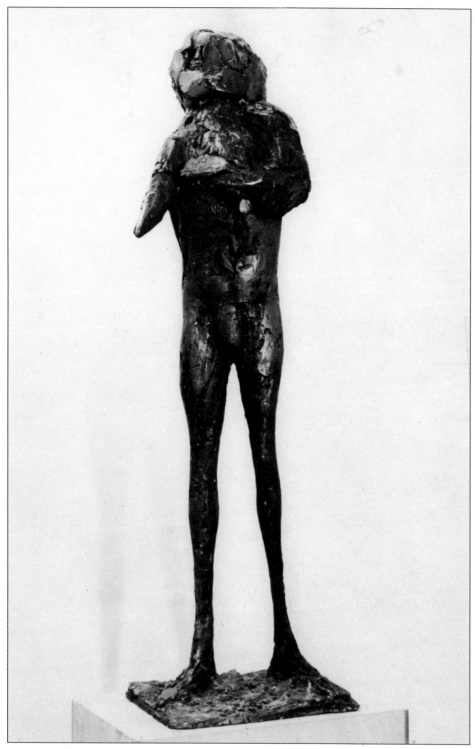

Sentinel I, *1961*
Bronze, edition of 4
51 in. high

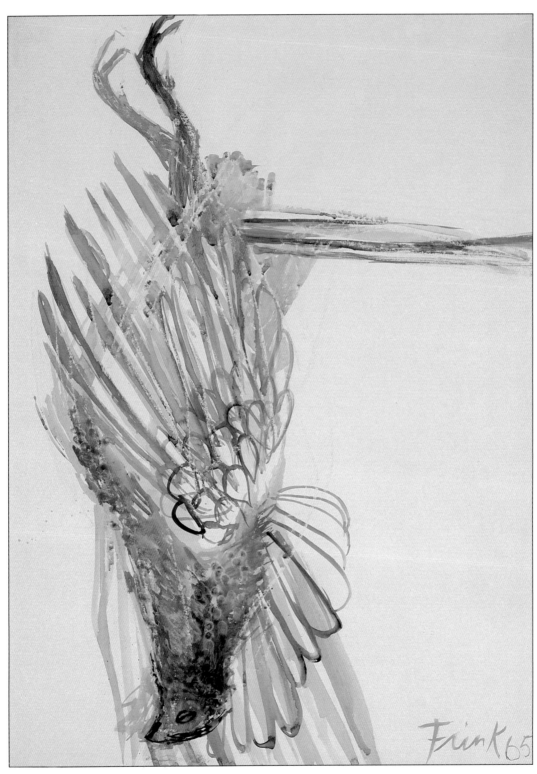

Dead Pheasant, *1965*
Watercolor
30 x 22 in.
Photograph by Edward Owen

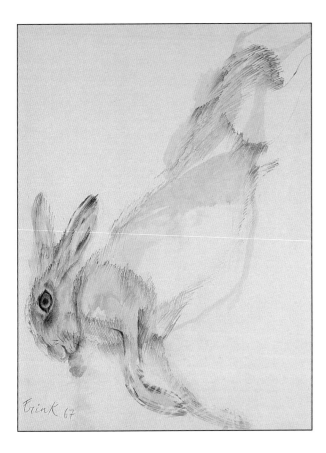

Dead Hare, *1967*
Watercolor and pencil
30 x 22 in.
Photograph by Edward Owen

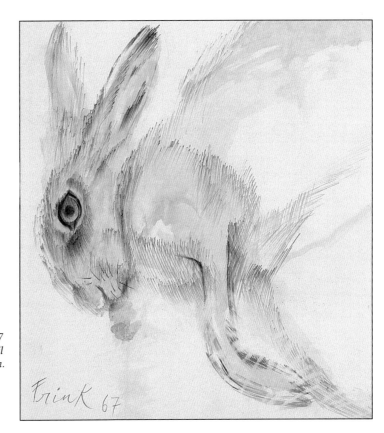

(Detail) Dead Hare, *1967*
Watercolor and pencil
30 x 22 in.

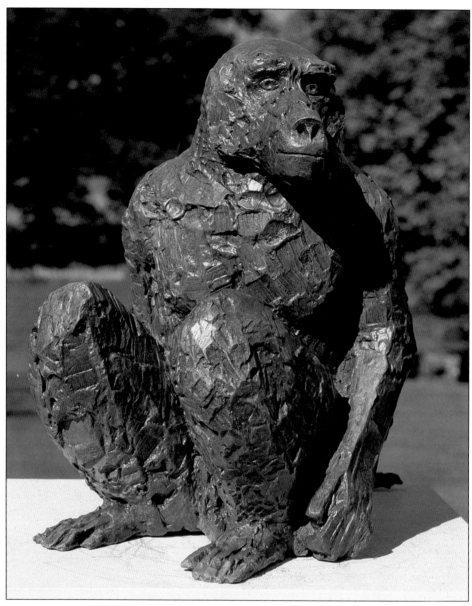

Seated Baboon, *1989*
Bronze
14 3/4 x 10 in.
Photograph by Jorge Lewinski

Man and Baboon, *1989*
Acrylic
78 x 58 in.
Photograph by John Morley

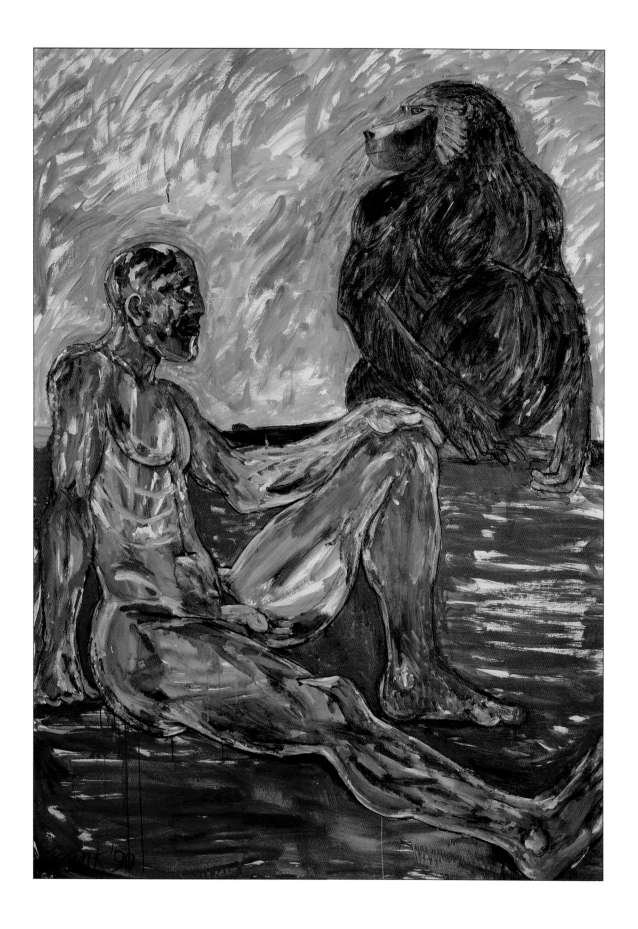

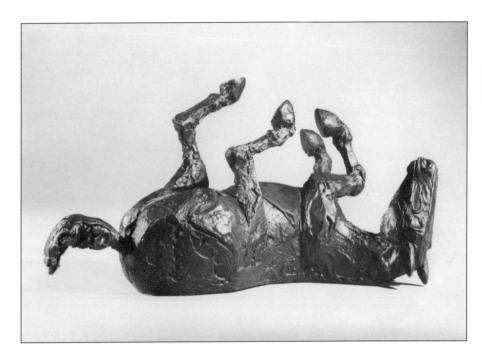

Rolling Horse, *1982*
Bronze, edition of 6
9 1/2 x 19 1/2 in.

Standing Horse, *1982*
Bronze, edition of 8
15 3/4 x 18 1/2 in.

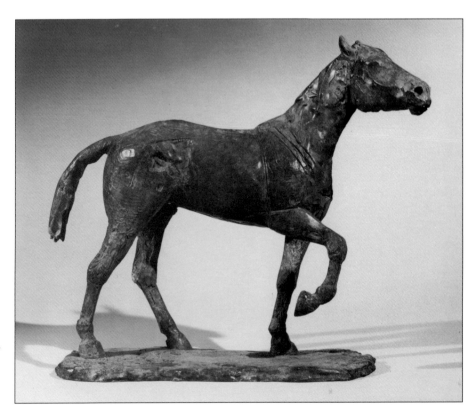

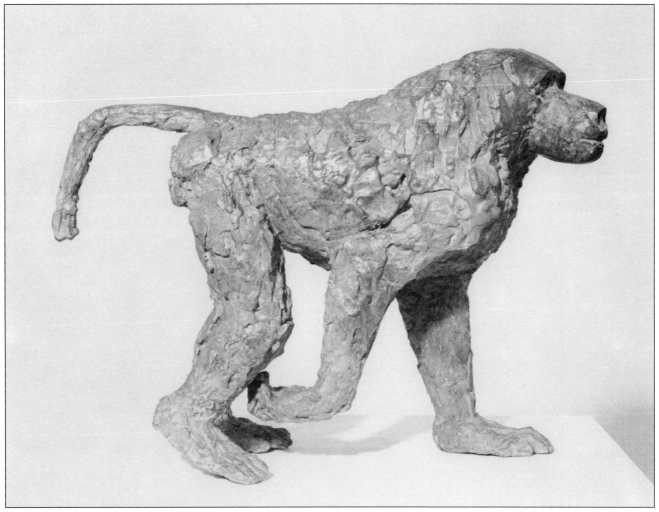

Baboon, *1989*
Bronze
11 3/4 x 15 in.

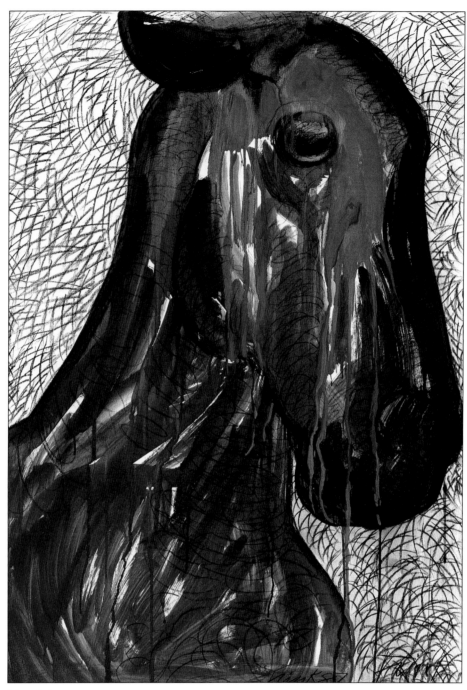

Wounded Horse, *1987*
Watercolor and charcoal
39 1/2 x 28 in.
Photograph by Edward Owen

PART III

THE ARTIST'S

COMMENTS

AND

NEW THEMES

"By the time I started at Chelsea I knew what I wanted to model. I had made some carving in wood and stone at Guildford, but I now wanted to model rather than to carve. My ideas seemed to come quickly. Many of them were concerned with movement in their nature—as in the bird forms—so that carving seemed too slow as a process to catch what I wanted to express. Quite quickly at Chelsea I started to use plaster of Paris on an armature of steel rods as a medium in itself, and not just as a stage in a longer, technical process. This eliminated the whole phase of taking a mold off the clay in plaster, which you had to do if you wanted to keep the piece or eventually have it cast in bronze. The technique of using plaster by itself was being used by Giacometti and Germaine Richier in France, as well as by Moore and others in England. I also learned to carve the plaster for final adjustments after the modeled form in plaster had hardened. Henry Moore did this to his plasters, and it gives to some aspects of the final cast bronze a tougher, carved effect, unlike the usual modeled surface.

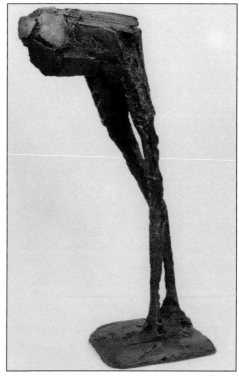

Large Bird, 1966
Bronze, edition of 6
20 3/4 in. high

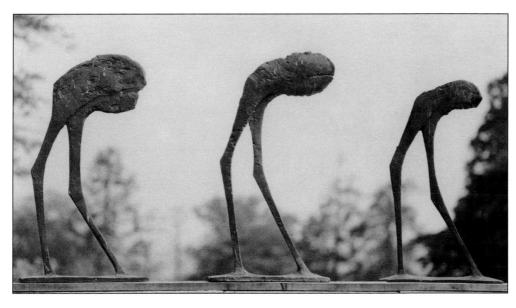

Mirage I, 1967 (L)
Bronze, edition of 5
35 3/4 in. high

Mirage II, 1967 (M)
Bronze, edition of 5
36 in. high

Mirage, 1967 (R)
Bronze, editon of 6
32 1/2 in. high

Excerpts from an interview conducted in the summer of 1984.

"Between 1949 and 1952 I was taking my sculptures to a considerable pitch of finish. The final form and the carving of the plaster were subordinate processes of rectification, emphasis or refinement. In recent years my approach has reversed itself: the sculptures are still built up in wet plaster on their armatures, but only to a roughly approximate stage of formal definition. The real attack in this technical process comes from a prolonged phase of carving on the dry plaster. In recent months I have felt the need, for the first time in my life, to make some direct carvings in stone.

"The birds I did in the early 1950s were really expressionist in feeling—in their emphasis on beak, claws and wings—and they were really vehicles for strong feelings of panic, tension, aggression and predatoriness. They were not, however, symbolic of anything else; they certainly were not surrogates for human beings or 'states of being.'

"I should say that my work has never been concerned with symbols or connected with anything other than what you see in front of you. If any symbolism is there, it is absolutely buried in my subconscious mind. But the birds at that time [the 1950s] were indeed implying more than the generalized physical body of a bird. They were specifically based on the forms of ravens and crows, and the war and violence around me must have been the reasons for my interest, at the time, in violence and aggression.

"The drawings of horses and riders of the early period, just before I went to Chelsea School of Art, were linked in my mind with reading the Apocalypse. I thought a good deal about riders and horses, and most particularly of the Four Horsemen of the Apocalypse.

"The Catholic religion gave me more reason to think about the beginnings of Western European art and the ways in which it was used by the church, because most of the art of the past that we look at

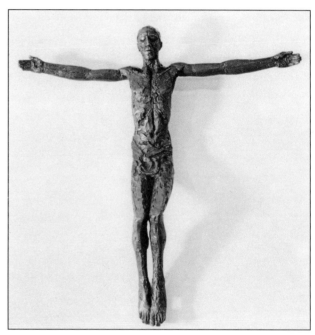

Crucifixion, *1983*
Bronze, edition of 6
27 in. high

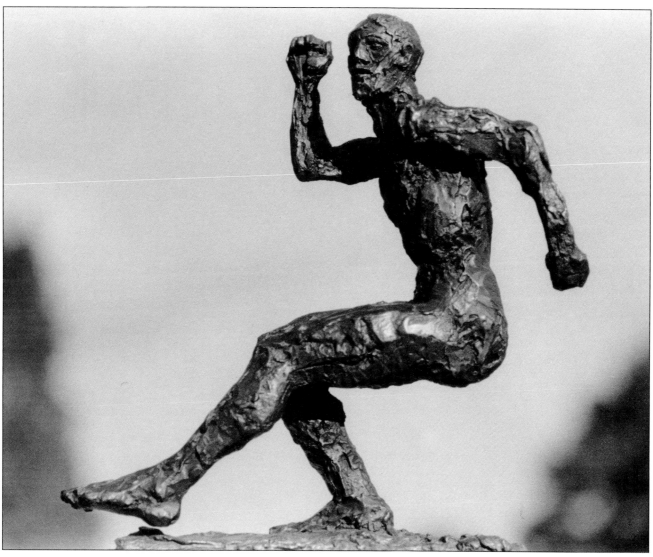

Leaping Man, *1987*
Bronze, edition of 8
14 3/4 in. high

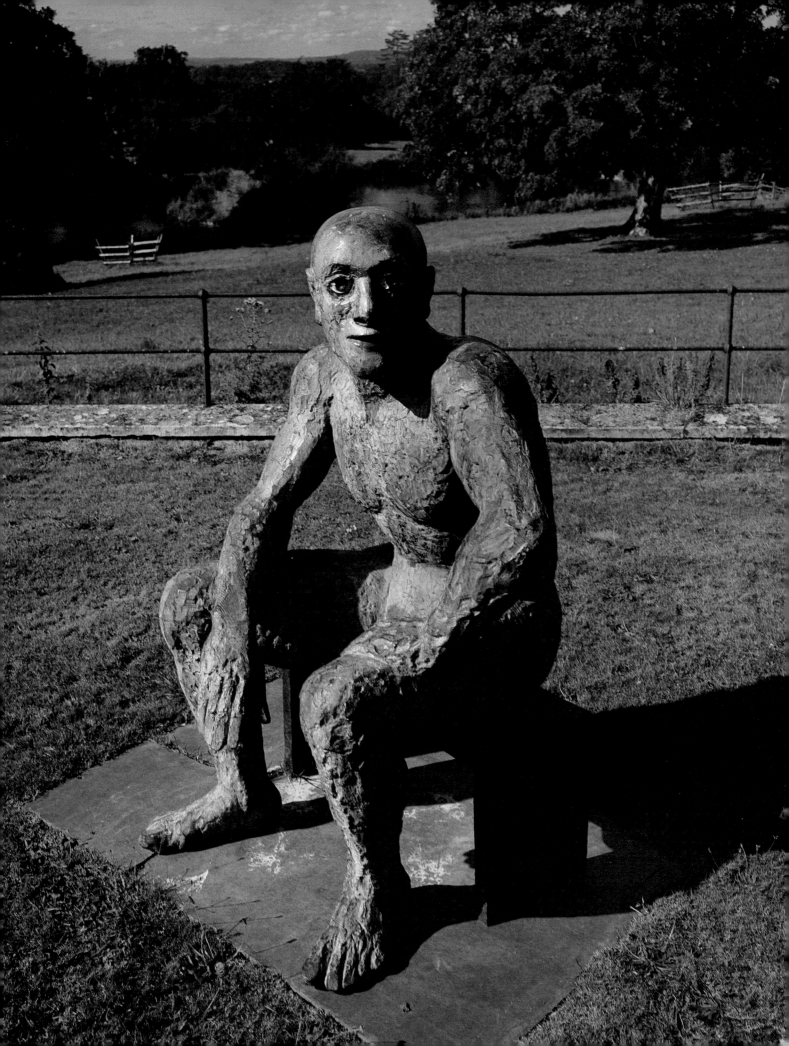

today had its roots in religion. Therefore, I feel that, as religion is a vocation for many people—and nuns and monks are solitary people—so art is a comparable vocation for artists, because of the solitariness of our work.

"What I have tried to make clear in my sculpture for the last five years or so is the way in which feeling, expression, even force and energy, should be below the surface. The outer skin may define more or less conventional features, but a second look should indicate the complex strains of nerve-endings and the anticipatory reflexes of something that is about to happen. A recent life-size sculpture in bronze of a seated man may convey some of this latent and interior energy in which feeling is implicit. The fluidity in Rodin, which is sometimes described as something like a painting, is a surface action, and in my sculptures, so far, this flow of plasticity or movement on the exterior would be an irrelevance.

"Giacometti's technique, that of building up directly in plaster on an armature, very happily confirmed my instincts because I began to work in this way myself even in art school, and I made some figures based upon these technical principles. Until Giacometti and Richier came along, it was more accepted to model in clay, but there are disadvantages in making intermediary casts. Apart from the technical approach, which I found immediately sympathetic, the sculptures themselves were imposing and had a stark presence for me that I had never sensed from reproductions. Only recently have I begun to comprehend fully for myself the extraordinary way in which a single figure by Giacometti or Richier can occupy a space as a physical fact of existence—almost as a visible reality with no props within the landscape or any other solid backdrops—as well as imply the dominance of a physical context beyond itself. The figure dramatizes, or at least conveys, its own environment.

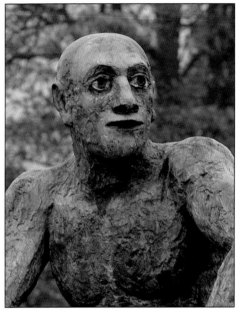

(Detail) Seated Man II, *1986*
Bronze
53 x 33 1/2 x 30 in.

(Opposite)
Seated Man II, *1986*
Bronze
53 x 33 1/2 x 30 in.
Photograph by Jorge Lewinski

"Thirty years ago I felt unable to convey the same sensation in my single figures and their occupation of space. Recently I have been concerned with the slightly different problems of making sculptures of groups of figures. Thinking along these lines, I have begun to realize that although Giacometti packed so much nervous apprehension of mass and movement, or repose, into comparatively attenuated forms, his articulation of space was certainly helped by the fact that his bases were usually rather shallow, but big in circumference and area. In this way the bases act almost as a stage, and the figures imply a drama through gesture or their still presence.

"Conversely, I did not warm wholly to Giacometti's world. When I first explored it at twenty-one, I did not understand fully why. Although I was used to stark and strange psychological elements in art, the work of Bacon for instance, and lived at this time with an ex-airman—a rear-gunner who had been shot down and taken as a prisoner of war, after which he had a leukotomy that still left him violent and temporarily unstable—my understanding, or at least acceptance, of neurosis still had not prepared me for the strange withdrawal in Giacometti's work and the pervading sense of despair. Instead of wanting to touch his sculptures and feel their form, I only wanted to stand back, and watch and come to terms with them through my eyes. In this way Giacometti's sculptures seemed cerebral. It was the implication of space and its attendant drama that touched me.

"I know now that my own sculptures are largely, though not entirely, classical in allegiance and, therefore, mostly, but not completely, outside or beyond the time flux. Giacometti's figures are, of course, ravaged by it, as well as eroded by interior, existential apprehension.

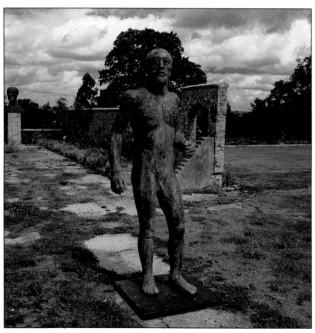

Riace II, *1987*
Bronze, edition of 4
86 in. high
Photograph by Jorge Lewinski

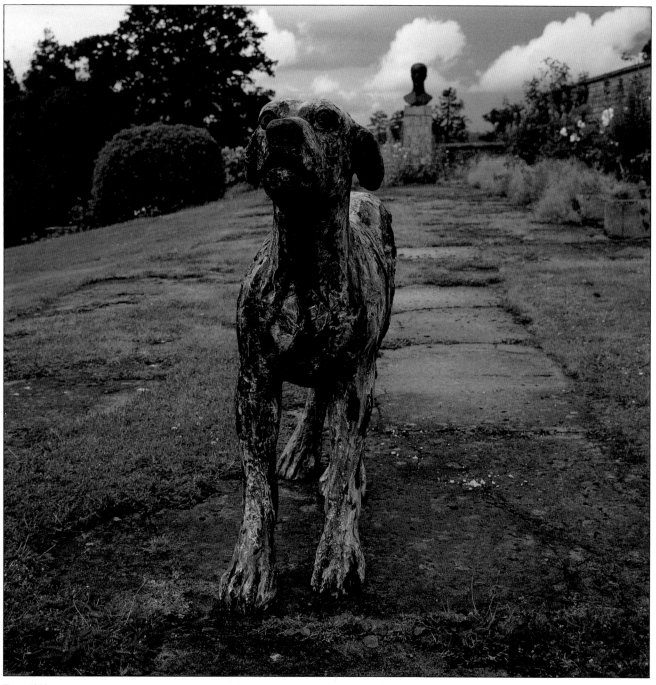

Dog, *1980*
Bronze, edition of 6
31 x 43 in.
Photograph by Jorge Lewinski

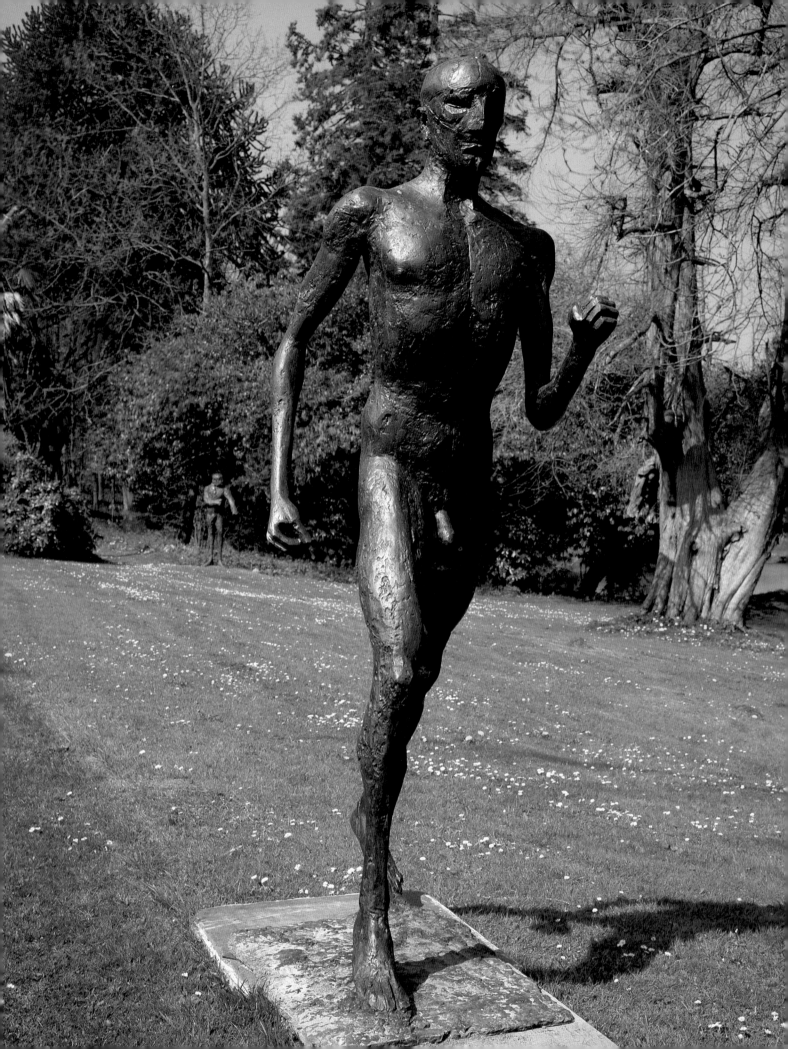

"Very recently, in 1983, when I was considering ways and means of making a group sculpture on the theme of the Dorset martyrs—a commissioned group for an outdoor site in Dorchester, near my part of the country, where these religious martyrs were executed in the 16th and 17th centuries for their beliefs—I began to work on my ideas for sculptures of people in groups, which can be explored by walking among them. Rodin's *Burghers of Calais* cannot be explored in this way because of its dense form. I understand now that, although Giacometti very rarely used more than two figures on a single, unifying base, his sculptures managed to invite you, as it were, to walk around them and between them. I used three or four figures based on a large area in the martyrs piece because I wanted as many people as possible to walk through the group. The sculpture is in a big, public place where everybody can walk. I dislike the idea of sculpture's being raised on a pedestal above people, with the exception of my monumental heads, which are conceived of as monuments and are larger-than-life in scale.

"My sculptures of the male figures represent both men and mankind. In these two categories are all the sources of all my ideas for the human figure. Men, because I enjoy looking at the male body and this has always given me, and probably always will, the impetus and the energy for a purely sensuous approach to sculptural form. I like to watch a man walking, and swimming, and running and being. I think that my figures of men now say so much more about how a human feels, rather than how he looks anatomically. I can sense in a man's body a combination of strength and vulnerability—vulnerability not as weakness, but as the capacity to survive through stoicism or passive resistance, and the ability to suffer or feel. My earlier sculptures of men in the '50s and '60s were a combination of men at war—for instance, the bird men, the spinning men,

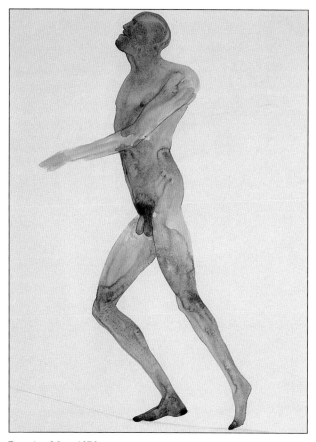

Running Man, *1976*
Watercolor and pencil
31 x 22 in.
Photograph by Edward Owen

(Opposite)
Running Man, *1980*
Bronze, edition of 4
82 1/2 in. high
Photograph by Jorge Lewinski

49

men in flight and men in space. These sculptures were the closest I came at the time to subjective ideas or the concept of a man's being involved in some kind of activity other than simply existing. So my earlier figures were not at all sensuous; they were too much involved with fractured wings or the debris of war and heroics. By this last phrase I mean individual courage.

"As I have grown older and the war years have receded, I have become far more interested in how the human figure really *is*, or how I can use it to embody or convey what I feel about mankind and what I feel about men, and not necessarily in the same figure. For instance, I have made one or two sculptures of standing men which are totally relaxed and physical, in the sense that the sculpture is a man standing there with no other motive beyond his physical presence, no symbolism. *Man* [1970] stands with his arms folded, and he is totally contained within himself. This applies equally to one of my latest figures, *Seated Man*, which I already described.

"I feel that I shall go on to make many more nude figures, because in the 1970s the running man became for me a dominant theme, and this was not entirely a sensual approach to the male nude. These running figures had a certain symbolic character. Although I have said that my work has never been concerned with symbols, these sculptures represent a human condition or sensibility. They are not just men running in a landscape; they are fugitive also—either running away from something or running to something. These figures have a political element because I am preoccupied with the human rights situation in the world at this moment, and this preoccupation feeds itself or finds expression in my mankind sculptures. My sculptures are either mankind or men, and they alternate or come in quite separate phases.

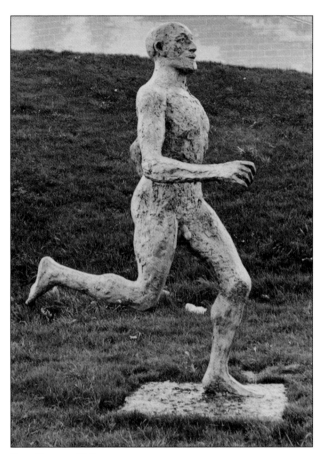

Front Runner, 1986
Bronze
Photograph by Jorge Lewinski

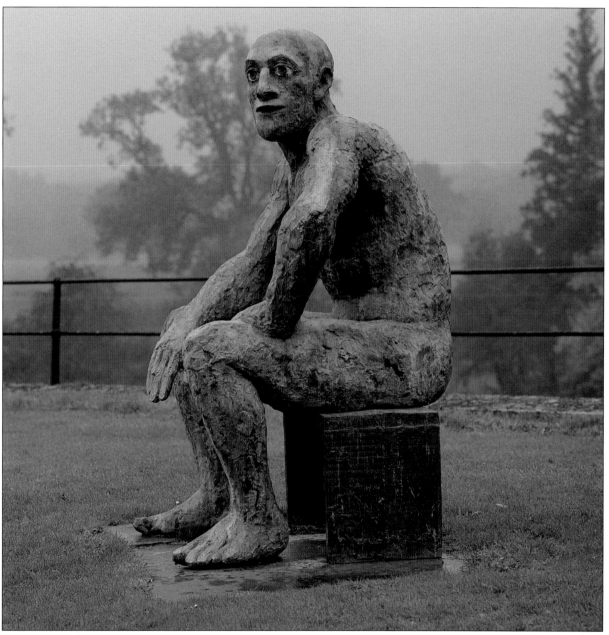

Seated Man II, *1986*
Bronze
53 x 33 1/2 x 30 in.
Photograph by Jorge Lewinski

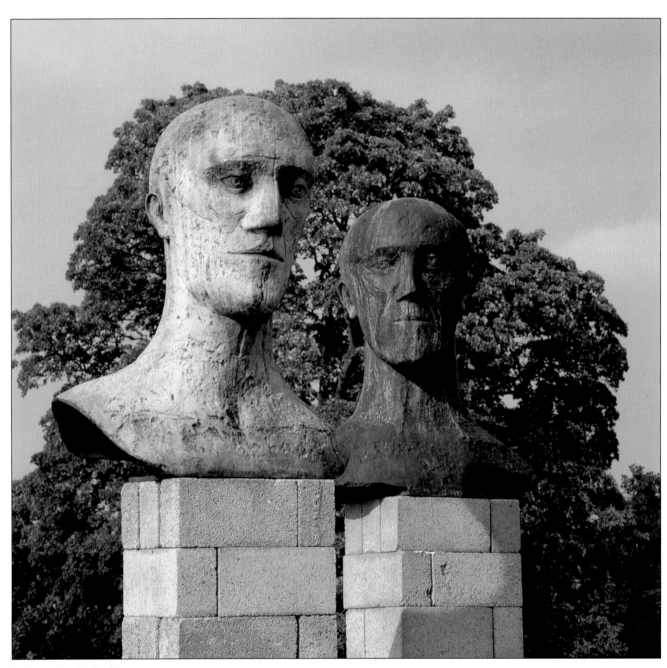

In Memoriam I & II, *1981*
Bronze, editions of 6
50 in. high each
Photograph by Mark Fiennes

"My concern is not that mankind is any worse than it was. It is just that it is as bad as it was. The media relays news of the horrors to us more quickly than was possible in the Dark Ages, and we are living in another Dark Age of inhumanity. We are becoming brutalized; we no longer respond properly to the atrocities. But I am basically an optimist, and I like to look at the male figure and enjoy it without it's being caught up in extraneous situations of aggression or flight.

"The soldiers' heads were started in 1964 in England and led on to the goggle heads, which were the reflection of my feelings about the Algerian war and the Moroccan strongmen. One, called Oufkir, was held largely responsible for the death of the Algerian freedom fighter Ben Barka. Oufkir had an extraordinarily sinister face—always in dark glasses. These goggle heads became for me a symbol of evil and destruction in North Africa and, in the end, everywhere else.

"The group of heads that I started in 1975, a group of four heads with their eyes shut, are the *Tribute* heads and refer to people who have died for their beliefs. In a sense these sculptures are a tribute to Amnesty International. The heads represent the inhumanity of man—they are the heads of victims. The more recent heads of 1981, which I call *In Memoriam* and which form a pair, have their eyes open but are still an extension of the same theme: people who have been tortured for their beliefs, whatever they are. Recently I have completed another monumental head related to these two."

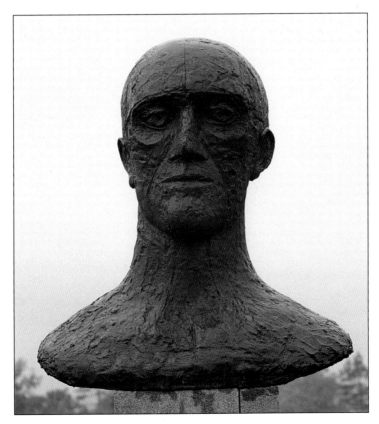

In Memoriam III, 1983
Bronze, edition of 6
55 in. high
Photograph by Jorge Lewinski

(Detail) Judas, 1963
Bronze, edition of 3
75 in. high

The inspiration for Elisabeth Frink's most recent standing or striding figures, heroes or soldiers, came from the recently discovered Riace warriors, 5th-century Greek bronzes found in the sea off the southern Italian coast. These great bronzes have a ferocity about them that tends to unsettle conventional thinking about the poise and balance of the classical world. As Frink has pointed out, however, the so-called Greek heroes were often mercenaries or thugs, always going off to do battle, and they had to be placated with offerings made to them through ritual sacrifice. Her huge figures, derived from the Riace discoveries, are stained as with blood, or marked to suggest damage from the flames of pillage and destruction. Looking at them we remember the catastrophes, the terror and the violence in the plays of Aeschylus.

Frink also has made some new monumental heads of unearthly serenity and detached, inscrutable calm. They are superhuman, unlike the earliest, aggressive, murderous heads with shades (*Judas* was her first sculpture to have covered eyes) or the more recent, stoic, "prisoners of conscience" heads, almost martyr-like in their pained acceptance. These new heads are illuminated by a flurry of small, regular chisel marks. The shallow, even indentations give the simplified heads an ethereal glow akin to rippling light moving across fast-flowing water. These heads, affecting in impact, are not murderers or martyrs but inner-communing receptacles of enlightenment and peace.

These new heads and the radical use of color in the Riace-based figures reflect Elisabeth Frink's ever-evolving vision. Her sense of humanity, straight from the heart, is a constant factor in her work, but her language, her vocabulary, is shifting and expanding. Like one on a quest or pilgrimage, she makes her journey alone. She still works without assistance.

Judas, 1963
Bronze, edition of 3
75 in. high
Photograph by Jorge Lewinski

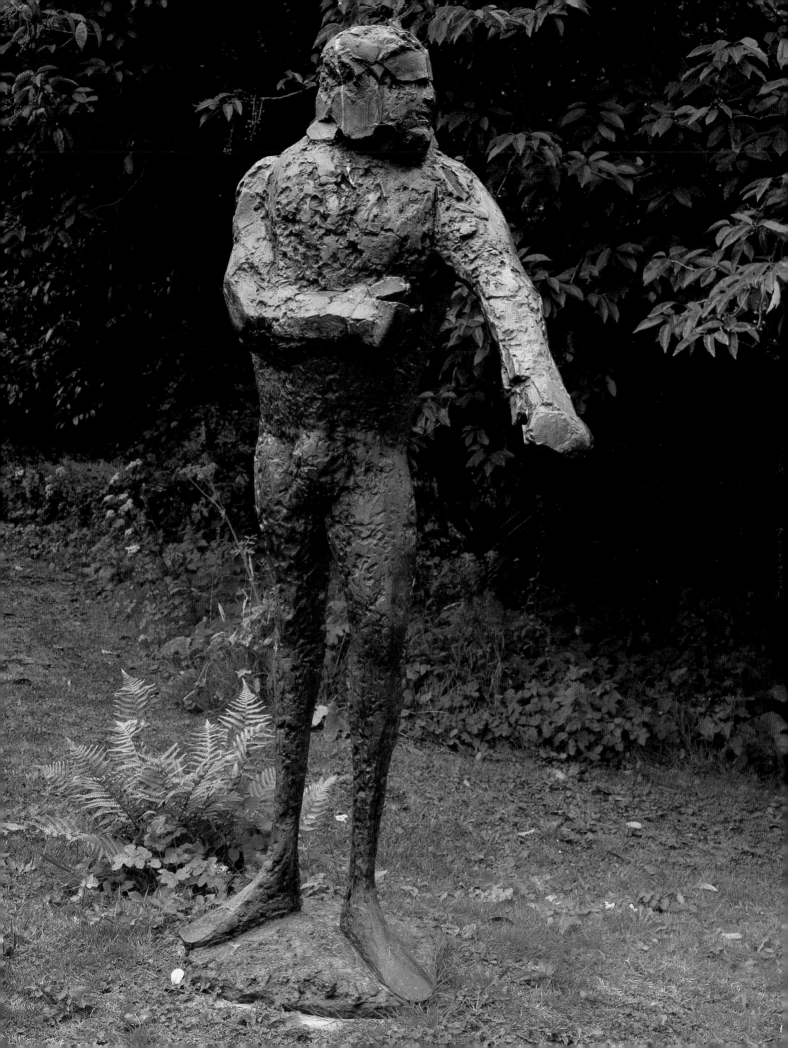

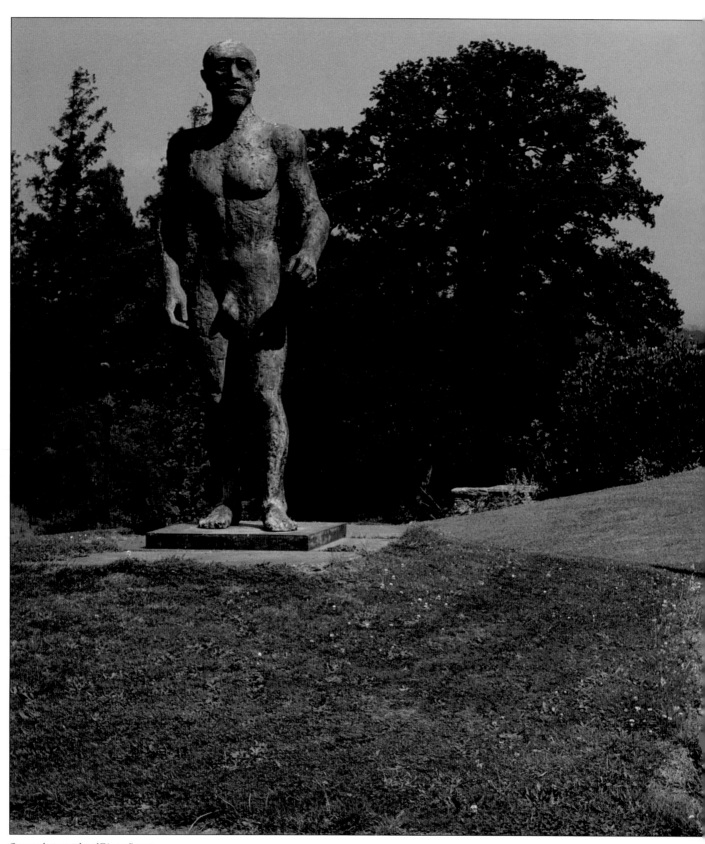

Group photographs of Riace *figures,*
1986-87, Dog *and* In Memoriam II, *1981.*
Photograph by Jorge Lewinski

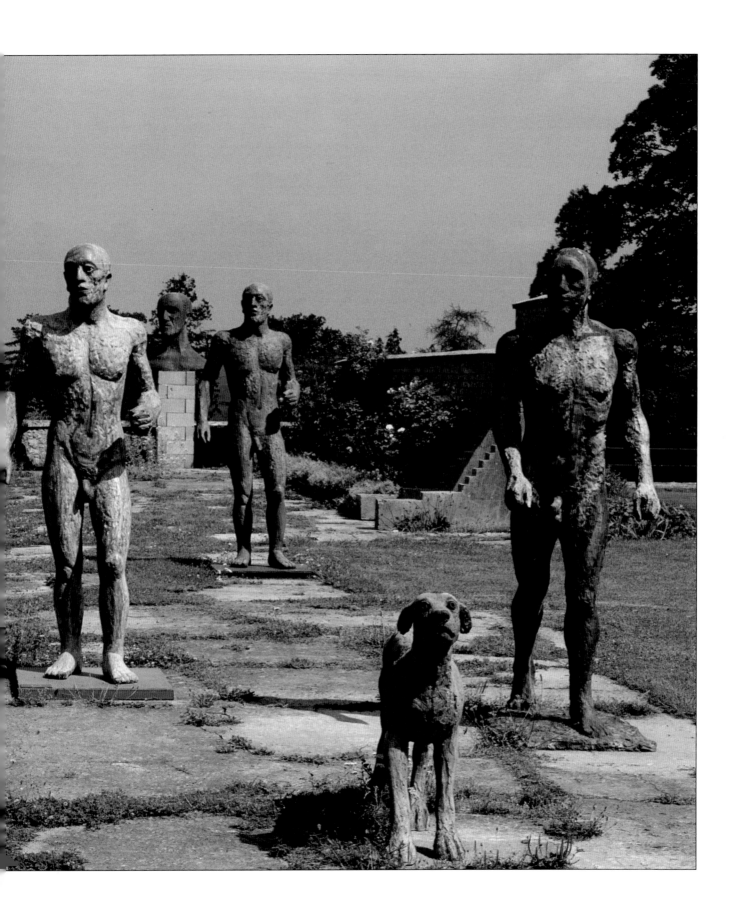

Head, *1968*
Watercolor and pencil
30 x 22 in.
Photograph by Edward Owen

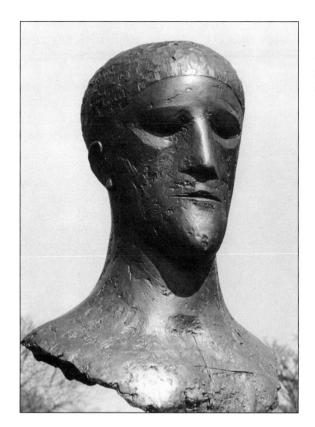

Tribute I, *1977*
Bronze, edition of 6
36 in. high

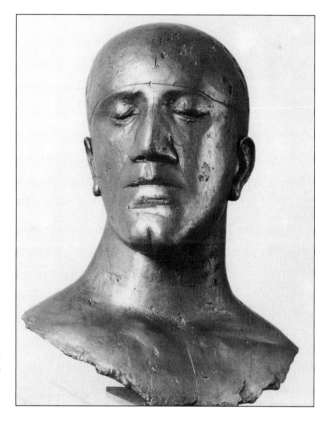

Tribute I, *1975*
Bronze, edition of 6
27 in. high

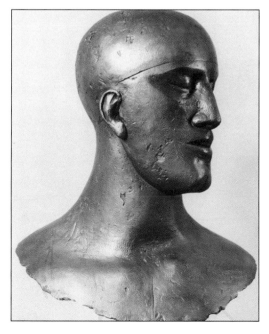

Tribute II, *1975*
Bronze, edition of 6
27 1/2 in. high

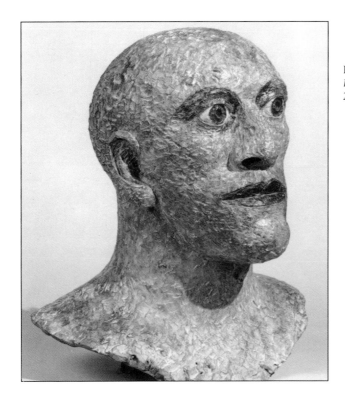

Easter Head II, *1989*
Bronze, edition of 6
20 x 18 in.

Easter Head I, *1989*
Bronze, edition of 6
19 1/2 x 20 in.

Head, *1988*
Acrylic and chalk
39 x 28 in.
Photograph by Edward Owen

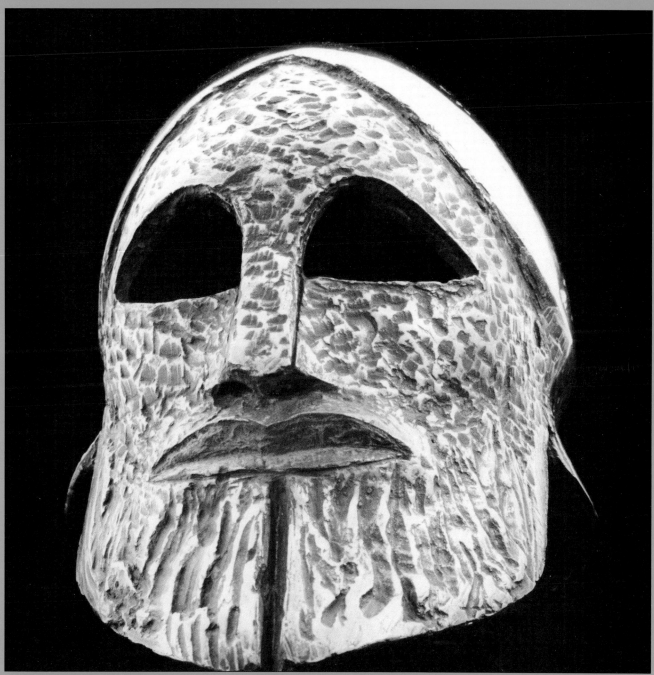

Midas Head, *1989*
Bronze, edition of 10
12 1/2 x 10 in.

EXHIBITION CHECKLIST

Sculpture

Horse and Rider, 1950
Bronze, edition of 3
30 in. high
On loan from Benjamin D. Bernstein

Bird Man II, 1958
Bronze, edition of 6
21 1/2 in. high
On loan from the artist

Dog, 1958
Bronze, edition of 4
38 x 38 in.
On loan from the artist

Torso, 1958
Bronze, edition of 3
13 x 39 in.
On loan from the artist

Winged Figure, 1959
Bronze, edition of 6
24 in. high
On loan from Edward J. Bernstein

Spinning Man II, 1960
Bronze, edition of 3
19 x 72 in.
On loan from the artist

Cock, 1961
Bronze, edition of 9
25 in. high
On loan from Benjamin D. Bernstein

Fallen Birdman, ca. 1961
Bronze, edition of 3
21 5/8 x 62 7/8 x 34 3/8 in.
Hirshhorn Museum and Sculpture
Garden, Smithsonian Institution
Gift of Joseph H. Hirshhorn, 1966

Falling Man, 1961
Bronze, edition of 6
27 in. high
On loan from the artist

Sentinel I, 1961
Bronze, edition of 4
51 in. high
On loan from Benjamin D. Bernstein

Assassins II, 1963
Bronze
20 1/2 in. high
On loan from the artist

Carapace I, 1963
Bronze, edition of 6
10 1/2 x 12 1/2 in.
On loan from the artist

Carapace II, 1963
Bronze, edition of 6
12 x 24 in.
On loan from the artist

Dying King, 1963
Bronze, edition of 3
35 1/2 x 78 in.
On loan from Mr. and Mrs. Leo A.
Daly III

Horse's Head, 1963
Bronze, edition of 6
10 x 18 in.
On loan from the artist

Judas, 1963
Bronze, edition of 3
75 in. high
On loan from Benjamin D. Bernstein

Plant Head, 1963
Bronze
18 in. high
On loan from the artist

Soldier, 1963
Bronze, edition of 6
14 in. high
On loan from the artist

Warrior, 1963
Bronze, edition of 6
24 1/2 in. high
On loan from Edward J. Bernstein

First Man, 1964
Bronze, edition of 3
76 in. high
On loan from the artist

New Bird I, 1965
Bronze, edition of 6
21 1/2 in. high
On loan from Benjamin D. Bernstein

Soldier's Head IV, 1965
Bronze, edition of 6
14 in. high
On loan from Edward J. Bernstein

Bird with a Wing, 1966
Bronze, edition of 6
20 1/8 in. high
On loan from Edward J. Bernstein

Large Bird, 1966
Bronze, edition of 6
20 3/4 in. high
On loan from the artist

Mirage, 1967
Bronze, edition of 6
32 1/2 in. high
On loan from Benjamin D. Bernstein

Mirage I, 1967
Bronze, edition of 5
35 3/4 in. high
On loan from Benjamin D. Bernstein

Mirage II, 1967
Bronze, edition of 5
36 in. high
On loan from Benjamin D. Bernstein

Helmeted Man with Goggles, 1968
Bronze, edition of 7
26 3/4 in. high
On loan from Edward J. Bernstein

Goggled Head I, 1969
Bronze, edition of 6
24 in. high
On loan from Mr. and Mrs. Leo A.
Daly III

Man with Goggles, 1969
Bronze, edition of 6
44 in. high
On loan from Benjamin D. Bernstein

Man, 1970
Bronze, edition of 3
74 in. high
On loan from Benjamin D. Bernstein

Tribute I, 1975
Bronze, edition of 6
27 in. high
On loan from Edward J. Bernstein

Tribute II, 1975
Bronze, edition of 6
27 1/2 in. high
On loan from Edward J. Bernstein

Tribute III, 1975
Bronze, edition of 6
27 in. high
On loan from Edward J. Bernstein

Tribute IV, 1975
Bronze, edition of 6
26 in. high
On loan from Edward J. Bernstein

Wild Boar, 1975
Bronze, edition of 6
28 x 39 in.
On loan from Benjamin D. Bernstein

Rolling Over Horse, 1976
Bronze, edition of 9
15 1/2 x 6 in.
On loan from Edward J. Bernstein

Tribute I, 1977
Bronze, edition of 6
36 in. high
On loan from Benjamin D. Bernstein

Running Man, 1980
Bronze, edition of 4
82 1/2 in. high
On loan from Mr. and Mrs. Leo A.
Daly III

In Memoriam II, 1981
Bronze, edition of 6
50 in. high
On loan from Mr. and Mrs. Leo A.
Daly III

Rolling Horse, 1982
Bronze, edition of 6
9 1/2 x 19 1/2 in.
On loan from the artist

Standing Horse, 1982
Bronze, edition of 8
15 3/4 x 18 1/2 in.
On loan from Mr. and Mrs. Leo A.
Daly III

Crucifixion, 1983
Bronze, edition of 6
27 in. high
On loan from Evelyn Stefansson Nef

In Memoriam III, 1983
Bronze, edition of 6
55 in. high
On loan from Mr. and Mrs. Leo A.
Daly III

Lying Down Horse IV, 1985
Bronze
7 x 14 x 6 in.
On loan from Robert Liberman

Large Dog, 1986
Bronze, edition of 6
30 x 40 in.
On loan from Robert Liberman

Riace I, 1986
Bronze
83 in. high
On loan from the artist

Front Runner, 1986
Bronze
On loan from Mr. and Mrs. Leo A.
Daly III

Seated Man II, 1986
Bronze
53 x 33 1/2 x 30 in.
On loan from the artist

Leaping Man, 1987
Bronze, edition of 8
14 3/4 in. high
On loan from the artist

Riace II, 1987
Bronze
86 in. high
On loan from the artist

Riace III, 1988
Bronze
86 in. high
On loan from the artist

Baboon, 1989
Bronze
11 3/4 x 15 1/4 x 5 3/4 in.
On loan from the artist

Chinese Horse I, 1989
Bronze, edition of 8
13 x 18 1/2 in.
On loan from the artist

Chinese Horse II, 1989
Bronze, edition of 9
9 3/4 x 16 in.
On loan from the artist

Desert Quartet III, 1989
Bronze
50 x 49 x 32 in.
On loan from the artist

Desert Quartet IV, 1989
Bronze
49 x 44 x 32 in.
On loan from the artist

Easter Head I, 1989
Bronze, edition of 6
19 1/2 x 20 in.
On loan from the artist

Easter Head II, 1989
Bronze, edition of 6
20 x 18 in.
On loan from the artist

Midas Head, 1989
Bronze, edition of 10
12 1/2 x 10 x 13 in.
On loan from the artist

Riace IV, 1989
Bronze
87 in. high
On loan from the artist

Seated Baboon, 1989
Bronze
14 3/4 x 10 x 16 in.
On loan from the artist

Standing Horse, 1989
Bronze
19 1/4 x 19 1/4 x 7 3/4 in.
On loan from the artist

Walking Man, 1989
Bronze, edition of 8
21 3/4 x 7 x 11 1/2 in.
On loan from the artist

Drawings

Spinning Man, 1960
Charcoal
30 x 20 in.
On loan from the artist

Animal Heads, 1962
Charcoal
30 x 20 in.
On loan from the artist

Dying King, 1962
Charcoal
30 x 22 in.
On loan from the artist

Winged Beast, 1962
Charcoal
30 x 22 in.
On loan from the artist

Plant Head, 1964
Charcoal
22 x 30 in.
On loan from the artist

Plant Head, 1964
Charcoal
22 x 30 in.
On loan from the artist

Soldier, 1964
Charcoal
30 x 22 in.
On loan from the artist

Soldier's Head, 1964
Watercolor
30 x 22 in.
On loan from the artist

Dead Pheasant, 1965
Watercolor
30 x 22 in.
On loan from the artist

Head with Goggles, 1966
Watercolor and pencil
30 x 22 in.
On loan from the artist

Dead Hare, 1967
Watercolor and pencil
30 x 22 in.
On loan from the artist

Head, 1968
Watercolor and pencil
30 x 22 in.
On loan from the artist

Horse and Rider, 1971
Watercolor and pencil
30 x 40 1/2 in.
On loan from the artist

Running Man, 1976
Watercolor and pencil
31 x 22 in.
On loan from the artist

Study for Seated Man, 1986
Pencil and collage on canvas
70 x 46 in.
On loan from the artist

Dog, 1987
Acrylic and black chalk
39 3/4 x 28 1/2 in.
On loan from the artist

Lying Down Horse, 1987
Pencil
55 x 45 in.
On loan from Robert Liberman

Wounded Horse, 1987
Watercolor and charcoal
39 1/2 x 28 in.
On loan from the artist

Head, 1988
Acrylic and chalk
39 x 28 in.
On loan from the artist

Man and Baboon, 1989
Acrylic
41 x 37 in.
On loan from the artist

Study for Seated Man I, 1989
Acrylic
39 x 28 in.
On loan from the artist

Study for Seated Man II, 1989
Acrylic
39 x 28 in.
On loan from the artist

Wounded Horse, 1989
Acrylic
39 3/4 x 28 in.
On loan from Mr. and Mrs. Gerald
 L. Parsky

Wounded Horse, 1989
Acrylic
39 3/4 x 28 in.
On loan from the artist

Man and Baboon, 1990
Acrylic
68 1/2 x 48 in.
On loan from the artist

Man and Horse, 1990
Acrylic
69 x 48 1/2 in.
On loan from the artist

Man and Baboon, 1990
Acrylic
46 x 46 in.
On loan from the artist

Man and Baboon, 1990
Acrylic
68 1/2 x 48 in.
On loan from the artist

BIOGRAPHY

Born in Thurlow, Suffolk, England, November 14, 1930.

Studied at Guildford School of Art, 1947-49; Chelsea School of Art (under Bernard Meadows and Willi Soukop), 1949-53.

Taught at Chelsea School of Art, 1953-61; St. Martin's School of Art, 1954-62. Visiting instructor at Royal College of Art, 1965-67.

Won prize in competition for "Monument to the Unknown Political Prisoner," 1953; Awarded CBE, 1969; elected Associate of the Royal Academy, 1971; appointed Trustee, Welsh Sculpture Trust, 1981; awarded DBE, 1982; awarded Doctorate by Royal College of Art, 1982.

Awarded Honorary Doctorates by University of Surrey, 1977; Open University, 1983; University of Warwick, 1983; University of Cambridge, 1988; University of Exeter, 1988; University of Oxford, 1989; University of Keele, 1989.

SOLO

1955 St. George's Gallery, London

1959 Waddington Galleries, London
 Bertha Schaefer Gallery, New York

1961 Waddington Galleries, London
 Bertha Schaefer Gallery, New York
 Felix Landau Gallery, Los Angeles

1963 Waddington Galleries, London

1964 Bertha Schaefer Gallery, New York
 Felix Landau Gallery, Los Angeles

1965 Waddington Galleries, London
 Curwen Gallery, London

1967 Waddington Galleries, London

1968 Waddington Galleries, London

1969 Waddington Galleries, London
 Thoresby College, King's Lynn Festival

1970 Halesworth Gallery, Suffolk
 Hambledon Gallery, Blandford

1971 Waddington Galleries, London

1972 Waddington Galleries, London

1973 Kettle's Yard Gallery, University of Cambridge

1974 Maltzahn Gallery, London

1975 David Paul Gallery, Chichester

1976 Waddington Galleries, London
 Collectors' Gallery, Johannesburg

1977 Waddington Galleries, Montreal
 Galerie D'Eendt, Amsterdam
 Yehudi Menuhin School, Cobham

1978 Bohun Gallery, Henley-on-Thames
 Salisbury Playhouse, Salisbury
 Terry Dintenfass Gallery, New York
 Waddington and Shiell Galleries, Toronto
 The Russell-Cotes Modern Artists Exhibition,
 Bournemouth

Artist in Her Studio, 198
Photograph by David Bucklan

1980 Waddington Galleries, London
Salisbury Arts Centre, Salisbury

1981 Waddington Galleries, London
Great Courtyard, Winchester
Hambledon Gallery, Blandford
Bohun Gallery, Henley-on-Thames

1982 Dorset County Museum, Dorchester
Beaux Arts Gallery, Bath
Halesworth Gallery, Suffolk

1983 Bohun Gallery, Henley-on-Thames
Yorkshire Sculpture Park, Bretton Hall
Terry Dintenfass Gallery, New York

1984 University of Surrey, Guildford
St. Margaret's Church, King's Lynn

1985 Royal Academy of Arts, London
Fitzwilliam Museum, Cambridge
Waddington Graphics, London

1986 Beaux Arts Gallery, Bath
Poole Arts Centre, Poole
David Jones Art Gallery, Sydney, Australia

1987 Beaux Arts Gallery, Bath
Coventry Cathedral, Coventry
Chesil Gallery, Portland, Dorset (graphics)
The Arun Art Centre, Arundel
Bohun Gallery, Henley-on-Thames

1988 Keele University, Staffordshire
Ayling Porteous Gallery, Chester (graphics)

1989 Hong Kong Festival, Hong Kong
Fischer Fine Art, Ltd., London
Lumley Cazalet Gallery, London (graphics)
New Grafton Gallery, London (drawings
retrospective)

GROUP

1952 Beaux Arts Gallery, London

1954 *Sculpture in the Open Air,* Holland
Park, London

1955- *Junge Englische Bildhauer: Plastiken und*
1956 *Zeichnungen,* British Council traveling
exhibition, Germany

1956- *Yngre Brittiska Skulptörer,* British
1957 Council/Riksförbundet för Bildande Konst
traveling exhibition, Sweden

1956 *Some Contemporary British Sculpture,*
Aldeburgh Festival

1957 *Sculpture 1850 and 1950,* Holland
Park, London
John Moores Exhibition, Liverpool

1959 John Moores Exhibition, Liverpool
Biennale voor Beeldouwkunst,
Middelheimpark, Antwerp

1960 *Sculpture in the Open Air,* Battersea
Park, London

1962 *Frink: Bell: Golding—Three Aspects of
Contemporary Art,* Whitworth Art
Gallery, University of Manchester

1963 *Sculpture: An Open Air Exhibition of
Contemporary British and American Works,*
Battersea Park, London

1968 East Kent and Folkestone Arts Centre

1970 Waddington Galleries, Montreal

1971 Summer Exhibition, Royal Academy, London
Park Square Gallery, Leeds
Balcombe Galleries, Sussex

1972 Summer Exhibition, Royal Academy, London

1973 Summer Exhibition, Royal Academy, London
Curwen Gallery, London

1974 Summer Exhibition, Royal Academy, London

1975 Summer Exhibition, Royal Academy, London
Halesworth Gallery, Suffolk

1976 Summer Exhibition, Royal Academy, London
Arts Club, London

1977 *A Silver Jubilee Exhibition of Contemporary
British Sculpture*, Battersea Park, London
Hambledon Gallery, Blandford
Royal Scottish Academy, Edinburgh

1978 Summer Exhibition, Royal Academy, London
Annual Exhibition, Hayward Gallery, London
Royal Scottish Academy, Edinburgh

1979 Summer Exhibition, Royal Academy, London
Russell Cotes Art Gallery and Museum,
Bournemouth
Royal Scottish Academy, Edinburgh

1980 *Women's Images of Men*, Institute of
Contemporary Arts, London
Biennale, Varese, Milan

1980- *Growing Up with Art*, Leicestershire
1981 Collection for Schools and Colleges,
traveling exhibition

1981 Waddington Galleries, London
British Sculpture in the Twentieth Century,
Whitechapel Art Gallery, London
Sculpture for the Blind, Tate Gallery, London
Halesworth Gallery, Suffolk
Twelve Sculptures to Touch, Portsmouth City
Museum and Art Gallery

1982 Summer Exhibition, Royal Academy, London
Annual Exhibition, Hayward Gallery,
London
Sculpture at Wells, Somerset
Women's Art Show 1550-1970, Nottingham
Castle Museum
Prophesy and Vision, Arnolfini, Bristol
Artist's Workshop, Newbury
Maquettes for Public Sculpture, Margam

1983 Summer Exhibition, Royal Academy, London
Royal Glasgow Institute of Fine Arts
Sculpture in a Country Park, Margam

BIBLIOGRAPHY

1959 Bowness, A. "Sculpture in the Ascendant
 in London Exhibitions." *Arts Magazine*,
 November.
"Elisabeth Frink at the Waddington
 Galleries."*Apollo*, July.
"Exhibition at the Bertha Schaefer Gallery."
 Art News, November.
"Exhibition at the Bertha Schaefer Gallery."
 Arts Magazine, November.
The Times, June 9; August 26;
 September 8; September 18.
Wheldon, H. *Monitor* (BBC film profile).

1960 Sandilands, G. S. "London County Council as
 an Arts Patron." *Studio*, February.

1961 "Brave New Patrons: Modern Sculpture on
 Three London Buildings." *Architectural
 Review*, September.
"Exhibition at the Bertha Schaefer Gallery."
 Art News, November.
"Figurative Renaissance: First Gallery
 Exhibits of the Fall Season." *Progressive
 Architecture*, November.
Griffin, H. "Elisabeth Frink." *Studio*, October.
Hodin, J.P. "Elisabeth Frink."*Quadrum*, 10.
Lee, L. (catalogue introduction). Felix Landau
 Gallery, Los Angeles, November.
Reichardt, J. "Elisabeth Frink at the
 Waddington Galleries." *Apollo*, July.
Sabbath, L. *Canadian Art Magazine*, May.
Tillim, S. "Exhibition at the Bertha Schaefer
 Gallery." *Arts Magazine*, December.

1962 Brookner, A. "Manchester: Annual Exhibition
 of Paintings by Young English Artists."
 Burlington Magazine, April.
Mullins, E. "Open-Air Vision: A Survey of
 Sculpture in London since 1945." *Apollo*,
 August.
Wheldon, H. *Monitor: An Anthology*,
 Macdonald.

1963 Burr, J. "Exhibition at the Waddington
 Gallery: Art School Manners."*Apollo*,
 December.
The Times, June 21; November 29.

1964 Read, Herbert. *A Concise History of Modern
 Sculpture*, Thames and Hudson.
Tillim, S. "Exhibition at the Schaefer Gallery."
 Arts, May.
Whittet, G. S. "Exhibition at the Waddington
 Galleries." *Studio*, February.

1965 Burr, J. "Black and White Prints at the
 Curwen Gallery." *Apollo*, December.
Coplans, J. "Art News from LA." *Art News*,
 February.
Grinke, P. *Financial Times*, December 22.
Laws, F. *Guardian*, December 11.
Mullaly, T. "Bronzes as Reflection of Artist."
 Daily Telegraph, December 8.
Mullins, E. "Grown-up Prodigies." *Sunday
 Telegraph*, December 5.
Robertson, B., J. Russell, the Earl of Snowdon,
 *Private View; The Lively World of British
 Art*, Nelson.
Spencer, C. *New York Times*, December 21.
The Times, March 1; March 29; December 6.
Wolfram, E. *Arts Review*, December 11.

1966 "Exhibition at the Schaefer Gallery."
Art News, Summer.
"Exhibition at the Schaefer Gallery."
Arts Magazine, September.
The Times, May 19; October 22.

1967 Gaunt, W. "Miss Frink's Sculpture."
The Times, December 8.
Gordon, A. "Elisabeth Frink: Spontaneity
and Optimism." *Connoisseur,* July.
Hammacher, A. M. *Modern English Sculpture,*
Thames and Hudson
Laughton, B. *Spectator*, December 15.
Robertson, B. "Frink Figures." *Arts Review,*
December 9.

1968 *Aesop's Fables*. Illustrated by Elisabeth Frink.
Alistair McAlpine/Leslie Waddington
Prints.
Gray, R. *Frink, Bratby, Barnes, Jackson*
(exhibition catalogue). East Kent and
Folkestone Arts Centre.
The Times, March 2.

1969 Bernstein, M. "Frink." *Observer,*
November 30.
Burr, J. "Exhibition at Waddington Galleries,
London." *Apollo,* December.
Field, S. "London: The Nude Naked." *Art and
Artists,* June.
Gordon, A. "Recent Sculpture: Exhibition in
London." *Connoisseur,* December.
Kenedy, R. C. "London Letter." *Art
International*, March.
Lynton, *N. Guardian*, December 16.
Martin, C., and J. Mossman. *Working in France*
(BBC film).
Mullaly, T. "Sculpture with Power of the
Prehistoric." *Daily Telegraph,* December 8.
Overy, P. *Financial Times*, December 9.

Raphael, D. "Gallery Reviews: Elisabeth
Frink." *Arts Review*, January 18.
Thomas, R. "Graphics." *Art and Artists,*
January.
The Times, January 22; June 14.

1970 Burr, J. "The Monster in Man." *Apollo,*
November.
Denvir, B. "London: Elisabeth Frink,
Waddington Gallery." *Art International,*
February.
Hall, D. "Six New Sculpture Acquisitions by
the Scottish National Gallery of
Modern Art." *Burlington Magazine,*
August.
Kirkman, T., and J. Heviz. "Arctic Determines
Eskimo Sculpture." *Montreal Star,*
November 25.
"Pollution." *Ark,* no. 47.
Reid, Sir Norman. "Art within Reach."
Observer, October 11.
Roberts, K. "Exhibition in London."
Burlington Magazine, January.
Savage, P. "Goggle-Eyed Obsession." *Sunday
Telegraph*, January 30.
Thomas, R. "Graphics." *Art and Artists,*
December.
The Times, July 23.

1971 Burton, H. *Aquarius—On Etching* (ITV film).
Parkin, M. "Elisabeth Frink: Portrait of a Well
Contented Artist." *Sunday Times,*
November 28.
Smith, L. "At Last, Off the Peg Sweaters for
£40." *Observer*, November 7.
Stockwood, J. "Queen's Counsel." *Harpers
and Queen*, August.
— ."Seven Figures in the Artscape." *Harpers
and Queen*, March.
"Sweaters." *Vogue,* December.

Thomas, R. "Graphics." *Art and Artists,* February.

1972 Chaucer, G. *Canterbury Tales*. Illustrated by Elisabeth Frink. Leslie Waddington Prints.

Frater, A. "The Mistress Etcher's Tale." *Daily Telegraph,* October 6.

Melville, R. "The Art of Being Literal." *Architectural Review,* December.

Mullins, E. *The Art of Elisabeth Frink*. Lund Humphries.

Vaizey, M. "Elisabeth Frink." *Arts Review,* October 21.

"Waddington Gallery, London Exhibition." *Art International,* December.

"Waddington Gallery, London Exhibition." *Burlington Magazine,* December.

1973 Day, A. *Arts Review,* August.

Hughes, G. "Modern Medals." *Crafts,* July/August.

"Waddington Gallery, London Exhibition." *Art International,* January.

1974 Homer. *Odyssey*. Illustrated by Elisabeth Frink. Folio Society.

Kilmartin, J. "The Diamond Stakes." *Observer,* July 28.

McLoughlin, J. "Jenifer Sees the Joke When It Comes to the Hanging." *Daily Telegraph,* May 1.

The Times, January 9; July 31.

1975 Hills, A. "New Frink Sculpture." *Arts Review,* August 22.

Homer. *Iliad.* Illustrated by Elisabeth Frink. Folio Society.

"Sculpture in Public Places." *Arts Review,* July 25.

The Times, January 9; July 31.

1976 Berthoud, R. "Elisabeth Frink: A Comment on the Future." *The Times,* December 3.

Gosling, N. *Observer,* December.

Green, E. "A Sensitive Feeling for Horses." *Argus,* April 13.

Hills, A. "Elisabeth Frink." *Arts Review,* December 10.

___ ."On a Human Scale: Inviting Touch and Comment." *In Britain,* September.

Katz, D., and L. Waddington. "Art Dealing: A Professional Approach." *Artlook,* February/March.

Lasserre, P. "Show That Can Be Seen Again and Again." *Cape Times,* April 27.

Mullaly, T. "Bronze Heads Dominate Frink Show." *Daily Telegraph,* December 8.

Simmons, R. "Bird Prints." *Arts Review,* April 16.

___ ."Iconography: Themes—Birds." *Arts Review,* April 16.

Spurling, J. "On the Move." *New Statesman,* December 10.

Strachan, W. J. *Towards Sculpture,* Thames and Hudson.

Sunday Times, December 19.

The Times, June 30; August 24.

Times Literary Supplement, December 3.

Walker, M. "Frink: Sitting Pretty." *Sunday Times,* November 21.

1977 Connell, B. "Profile." *The Times,* September 5.

Hughes-Hallett, L. "Elisabeth Frink, Sculptor." *Vogue,* July.

The Times, March 17; August 16.

"Waddington and Tooth Galleries, London: Exhibition." *Art International,* January.

1978 Connell, B. Film interview, Anglia TV.
 Kent, Sarah. "Elisabeth Frink." Hayward
 Annual exhibition catalogue.

1979 Freedman, A. "Horses, Men and Sculpture in
 the Grand Tradition." *Globe and Mail*,
 Toronto, September 8.
 Kramer, H. "Art: A Sculptor in Grand
 Tradition." *New York Times*, February 2.
 Nicolas-White, C. "Three Sculptors: Judd,
 Volmer and Frink." *Artworld*,
 February/March.
 "Terry Dintenfass Gallery, New York:
 Exhibition." *Art International*, May.

1980 Eastop, G. "Bohun Gallery, Henley, England:
 Exhibition Review." *Arts Review*, March.
 Kramer, H., and S. Kent. "Elisabeth Frink:
 Sculpture and Watercolours, 1964-79."
 Massachusetts Review, Spring.
 Palmer, T., and T. Bryan. Film, Southern TV.
 The Times, July 30.

1981 Beyfus, D. "Makers of Myth and Magic:
 Elisabeth Frink Monumental Energy."
 Vogue, June.
 Hughes, G. "Elisabeth Frink." *Arts Review*,
 June 5.
 Katz, J. "London." *Bedfordshire News*, June 21.
 Kent, S. *Sculpture in Winchester* (exhibition
 catalogue).
 Levin, A. "A Room of My Own." *Sunday
 Times*, June 7.
 Mayes, I. *Birmingham Post*, June 24.
 Mullaly, T. "The Magnetism of Frink." *Daily
 Telegraph*, June 15.
 Russell-Taylor, J. *The Times*, June 16.

 Sabbath, L. "Sculptor Prefers Males as
 Models." *Gazette*, Montreal,
 November 11.
 Shepherd, M. "Frink Piece." *Sunday Telegraph*,
 June 14.
 Slaughter, A. "Using Her Head." *Sunday
 Express*, July 19.
 St. John Stevas, N. Interview, BBC TV.
 The Times, May 28; December 21;
 December 31.
 Times Literary Supplement, June 5; June 16.

1982 *Arts Review*, August 13.
 Sunday Times, June 27.

1983 *Arts Review*, April 1; July 22.
 Brenson, M. *New York Times*, November 11.
 Hourahane, S. *Sculpture in a Country Park*,
 Welsh Sculpture Trust catalogue,
 Margam.
 McLeish, K. *Children of the Gods*. Illustrated by
 Elisabeth Frink. Longman.
 McManus, I. "Elisabeth Frink: An Open Air
 Retrospective." *Arts Review*, September 2.
 — .*Guardian*, August 30.
 Robertson, B. "Elisabeth Frink: Open Air
 Retrospective" (catalogue introduction).
 Yorkshire Sculpture Park.
 "Statue in the Best Tradition of Religion and
 Art." *Basingstoke Gazette*, May 20.

1984 *Art News*, February.
 Elisabeth Frink Sculpture (catalogue raisonné).
 Harpvale Books, Salisbury, Wiltshire.
 Gallati, B. *Arts Magazine*, January.